CREATIVE UTOPIA

CREATIVE UTOPIA
12 WAYS TO REALIZE TOTAL CREATIVITY

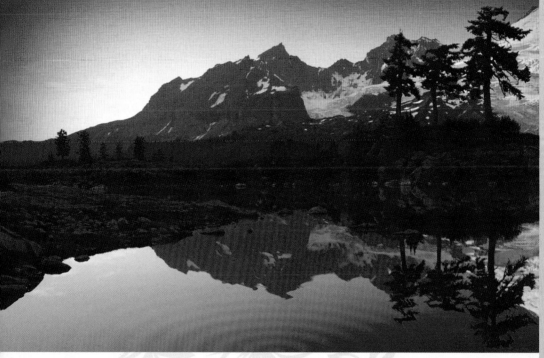

THEO STEPHAN WILLIAMS

HOW
DESIGN BOOKS
Cincinnati, Ohio
www.howdesign.com

06 05 04 03 02 5 4 3 2 1

Williams, Theo Stephan
 Creative Utopia: 12 ways to realize total creativity / Theo Stephan Williams.
 p. cm.
 Includes bibliographical references.
 ISBN 1-58180-173-4 (alk. paper)
 1. Creative ability. 2. Conduct of life. I. Title.

BF408 .W534 2002
153.3'5—dc21 2001051924

Editors: Ava Mueller and Clare Warmke
Editorial Assistance: Amanda Becker
Cover Designer: Real Art Design Group, Inc.
Interior Designer: Stephanie Strang
Production Coordinator: Sara Dumford
Page Layout Artist: Kathy Bergstrom

Dedication
To my husband Joel,
whose creativity far surpasses my own.

acknowledgments Thank you to Lynn Haller for being the first person to believe in my *Creative Utopia* manuscript; also to Julia Groh at F&W Publications for her wonderful negotiations style and enlightening, late-night conversations at the inception of this book. To Linda Hwang, my original editor, and Clare Warmke and Ava Mueller, the final editors, for being especially patient with due dates and very kind about substance. To Clare Finney, the art director at F&W, for allowing me to share ideas about the book's cover and format.

My mother deserves a poignant thanks for always believing in me and reminding me countless times that I could do whatever I put my mind to.

My sisters Renee and Kathy have both been creative models for motherhood and excellence in their teaching professions. We are each so different, yet our conversations are always enlivening. My nieces and nephews, Angel, Gregory, Demetri, Stephanie and Stephen, contribute to my creative inspiration more than frequently.

I am forever grateful to have many creative friends whose voices—whether verbal or nonverbal—inspire me with their originality.

Last, but never least, I am thankful for my Himalayan gems, Anita and Sunita, who remind me every day that creativity comes from the loving joy born within our hearts.

table of contents

Introduction 8

CREATIVE UTOPIA

Is creative utopia truly possible? Yes, and I'll

tell you why: Creativity is simply a perception. That's all, noth-

ing more. People in our society constantly endeavor to label

others. "Oh, she's beautiful with her streaming long hair." Or,

"He is so dynamic, the way he dresses and articulates him-

self." Adjectives in any form are perceptions. Anyone can be

anything, anytime, anywhere—including creative. And to ex-

perience one's own inherent creativity is truly a gift of free-

dom that will reward you with a utopia you may have previously

thought was only for "other" people.

My mother used to draw cute little pictures on my lunch sacks. I loved it as a small child but as I grew older it kind of embarrassed me until my 5th-grade boyfriend told me how cool he thought it was; no one else's' mom did that. Looking back, her endeavors were indeed creative, even though an art critic may not have labeled them as "artistic" they were creative nonetheless—and appreciated as such.

I just had some lock work done on my home and never having seen the locksmith before I decided to try an experiment.

"Do you think you are creative?" I asked him, seemingly out of the blue.

He looked at me strangely and then he looked behind me as if to see if anyone else was around—was I getting weird on him or what?

He replied, "What do you mean by that ma'am?" as though I had suggested something occult or mysterious.

"Well, you know, creative. Do you think you live any part of your life creatively?" I then had to blow my cover because he took a deep breath, rolled his eyes, and picked up his tool box. I really didn't want him going anywhere without fixing my locks, so I told him I was writing a book on creativity and doing some informal interviews with people on the subject. He put his tool box down and said, "Albert Einstein—now that's a creative man," proceeding to offer absolutely nothing more than suggesting I make my deadbolts the same as my knob locks to lessen the amount of keys to the place.

"Thanks for your creativity with that idea," I offered when he was finished. He kind of tried to smile, looked at me like I was a woman from Pluto and walked out to his truck, having no idea how much his proficiency (read: creativity) had actually made my key management more efficient. And, you

see, I had always perceived Albert Einstein to be unequivocally intelligent, not necessarily creative.

These are two examples showing perceptions of creativity. If you are fortunate enough to think of yourself as an artist, think about the many times you have felt yourself in a creative groove; then think of that horrible juxtaposition of the feeling that a monsoon is going through your brain, allowing you to produce nothing but maybe an outburst of windy frustration. Those moments don't reflect a time when you are not creative, simply a time when your creativity is not surfacing for some reason.

There is so much pressure on those of us who are labeled as "creatives" to be perpetually so. And for those of us who have creative desires within, but for whatever reason are too intimidated to express ourselves fully, or too busy, or too unsure, there is that pressure that if we were to take the risk and try to declare our creativity, there would be expectations from others—or even worse—ourselves.

I want this book to act as a concrete step toward guiding every reader to perceiving themselves as creative. This can be accomplished by first learning and then following the language of one's own personal "art" or creativity. Each chapter covers a different subject for those on their first personal quest or for those who know they are creative but feel mired in a domain of unproductivity, stuck in a pattern of dull awareness or general lack of creative genius. The end of each chapter includes several learnings that will act as reminders after you have finished the book, or might be useful in helping you decide which chapters you will want to read first.

introduction

It is my earnest hope that this book will give you many ideas on how to open your creative windows to the fresh breezes that await your endeavors. You don't have to read it all at one time. In fact, it might be best to read a chapter as you feel the need, as you feel exasperated or stressed because exasperation and stress are indeed themselves perceptions, and wouldn't it be wonderful if you could find your own personal utopia somewhere within your own creativity?

I look forward to hearing from those of you who become inspired from the pages that follow. Your stories of superseding your own perceptions of creativity greatly interest me.

—Theo Stephan Williams

SETTING GOALS FOR SUCCESS

1

The concept of establishing

goals may seem overrated, overused, otherwise abused and simply trite.
I'll be the first to admit that I am a self-help book junkie and I got so sick of
seeing the repetitive theme of goal planning in just about every piece of
self-motivational literature that it thoroughly disgusted me. But that was

> What is the use of running if we are not on
> the right way?
>
> —*German Proverb*

before I tried it; now I'm hooked. The goal-writing process itself can be cathartic and effective in helping focus on the here and now.

Typically, we're taught to look at goals as something that will result in a future reward or outcome. In this chapter I want to present goal setting as a way to better define your present. The energy, personal reflection and purposeful intent of creating your goals combine to yield the first harvest toward realizing your abundant, personal, creative utopia.

This book was literally conceived while I was suffering severe jet lag after a trip to Nepal to meet my now adopted daughters. I was lying in that lucid state between dreaming and wakefulness, hearing their playful laughter yet knowing that it would be months—years maybe—before the adoption would be complete. Suddenly a swell of ideas, emotions, desires overwhelmed me—everything at once, and everything revolving around time and questioning time.

My husband and I have a joke about those we refer to as "the busiest people in the world." We both know people very near and dear to us whose conversations always revolve around their business, their productivity, their lack of time to do other things, their besieged schedules, their anxieties. Now, here I was in bed, my heard spinning, wondering how and when I could ever consider my own creative aspirations with so many commitments at hand. I dreaded becoming one of those busiest people in the world!

To prove my point: I was selling the bulk of my design firm to my business partner while still servicing Universal Studios, one of our largest clients for at least the next year. I was in the second year of starting our family food product line, struggling to heed the branding and marketing advice I had been giving clients for years but, for whatever reason, had remained mostly ignorant of! I was in the middle of a huge ranch renovation project that was going to take a lot more time and money than I had anticipated. The deadline for another book I was rewriting for another publisher loomed like Cinderella's pumpkin, close at hand. Not to mention the fact that I had just committed to motherhood at age thirty-nine, with no inkling of what that might mean for me. And all the

setting goals for success

Our psychological self perceptions, sense of reasoning and self confidence are developed within us by the age of five.

while I've got a million and one "creative" ideas that I want to get to, but when? Someday, maybe. Tomorrow, never. Today? No way.

It was 4 a.m. I ran into my office and, as though I was having an out-of-body experience, wrote the entire outline for this book. Within a month my publisher had approved it. Selfishly, it was like writing a self-help manual for myself. I had my own answers from exploring my own inherent beliefs and interests throughout the years. Those same years of listening to those busiest people in the world, along with five years' worth of teaching college students and seventeen years of hiring (and firing) employees at my design firm, Real Art, make me realize that just about everyone has their own answers too. Those answers within you are the foundations for your primary set of goals.

Your first goal is to determine what your goals should be. Huh? Yes. Way too often we base our goals on what we think we "should" do, what we think others (parents, spouses, our children, friends, etc.) want us to do and what the media portrays as the "right" thing for us to be doing, all at the same time. No wonder we're dejected when we don't achieve our New Year's resolutions!

The fact is, if we are not intrinsically committed to our goals, we quite likely we will never reach them. If we do happen to attain them, the result might be temporary, the reward procured probably forgotten within a short time. What is the dynamic behind this force? For example, millions of Americans are on a diet every day; their reward of losing weight is often met with the yo-yo effect of their subsequently gaining it back. The answer is that most of them lost weight because of peer pressure; they felt they "should" due to their doctor's advice or lover's scorn. But the delight in that extra bite, cheese on the burger, chocolate in the shake, ultimately outdistanced the leaner, meaner options. The result is a huge letdown, while if one were to resolve never to diet but instead to eat three healthy squares a day, rewarding oneself a couple times a week with some extras, one would probably never gain weight, look forward to the rewards and become satisfied.

Now let's put that all into a creative perspective synonymous with goal *achieving*. First, check in with yourself. Get to a quiet place, totally disconnect from everything and everyone, and take a deep look into the cavern that is your artistic self. If you have never painted a picture, written a poem, taken a pretty photograph or considered yourself as owning even a pinhead of creative energy, go ahead and dive into this personal search.

setting goals for success

I listened with great interest recently to a talk radio show on National Public Radio (NPR) in which award-winning poet and author Lois-Ann Yamanaka was discussing how her cultural conflicts had given her great insight into her writings. Lois-Ann is Hawaiian and has written some outstanding books in pidgin, a commingled Hawaiian creole English.

I called into the station and asked her, "Do you perceive yourself to be creative or do you believe your creativity is a particular by-product of your culture?"

She replied, "Like my grandmother always told me, 'You have a gift, now you need to use it.'" We all have some type of creative gift. It might not be the same as that of a distinguished, renown talent; it can be small or large. But pursuing your gift, purposefully learning more about it, will expand your personal sense of being and lifestyle in a very positive way.

So be focused and definitive while discovering your own gift(s) and setting your first goals; don't hold anything back. Obtain a small notebook or something you can carry with you inconspicuously so you can review your goals daily. Your goals are points of convergence with detailed instructions that will guide you to a successful result. Without establishing subdivisions to act as stepping-stones, it will be too easy to drift off course or become disillusioned along the way.

For example, one of my goals was to sell this book concept to a publisher, with the details or secondary goals being to write the book in a more intellectual style than my previous books; use a credible reference list; cite sources with high integrity; finish within a certain time frame; and appeal to a larger audience than my other writings to date. All of this was included in my written goal versus simply "write this book," period. After I got the contract to write the book, I broke down each

chapter into its own set of goals that I could attain by following a challenging outline.

It takes a genuine commitment to behavior modification to prepare a real goal, refer to it frequently and realize its potential. If you are devising a goal for any reason other than for your own personal compensation you're heading down the wrong road. Don't put yourself into check by setting yourself up to fail; that's checkmate time! How many people can you name who play the victim, continually blaming other people or unfavorable circumstances for their lack of achievement? These people are putting themselves into a checkmate situation. Sadly, they will never win the game.

You can win by being altruistic to your inner self, setting goals that have absolutely nothing ostentatious surrounding their reality and creating a discipline for yourself that will be enjoyable to monitor. Uh-oh, I used the *d* word. The words *discipline* and *structure* can sound like huge impediments to creative people; I know this firsthand. It took me years to understand that by embracing concepts, I could realize my own constant goals and desires for increased productivity and project completion. My best weeks are those about which I can say that I worked hard and played hard. I've finally grasped the fact that only via discipline and structure can I continually realize that weekly goal.

Goal One on your list for finding creative utopia should be to buy a calendar, cherish it and refer to it at several times a day. I learned a powerful and humbling lesson the day my traffic coordinator at Real Art beseeched me to take all the little self-sticking notes off my desk, clear away my superfluous scraps of paper, my piles of stuff I was never going to get to, even with the best of intentions, and begin using a DayPlanner.

setting goals for success

Now, I'm not a stockholder in that company. In fact, I have friends that have left their paper calendars to gather dust, preferring a Palm Pilot, Visor or any of the countless other electronic options available. My point is this: Find a calendar medium that works for *you*, one that you will keep with you wherever and whenever you go, that will become your alter ego. My personal preference for paper revolves around my love for doodling, my propensity to keep a journal, my frequent bad habit of writing something down while I am driving and the wonderful realization that one can actually drive over a paper calendar without crushing the very life out of it. Sure, it will have some tire tracks on it, but it will at the very least still be useful, not reduced to shattered fragments of ineffectual plastic!

Your goal(s) will play an active role in your life if you make them a part of your daily activities, thus the *structure*. Every day should include a small part of the whole of your goal. Use your calendar to enter every step you will need to take to make it happen, every day, even if it is simply to ponder the goal, to mull over it with a confidant, to look for reference material that will support your goal endeavors.

Don't expect too much too quickly. Set up rewards for yourself along the way, things to look forward to, goals within the goals. We humans are not too keen on failure or rejection. Give yourself the resources and time to succeed. If you start to question the feasibility of the goal, take off a day or two. Like a painting or a sculpture, sometimes walking away and looking at a project with a fresh eye after a little (not too much!) time has passed will enhance the subject matter, or it might encourage you to start over on a more selective path.

Whatever your desire, learn to visualize it as authentic. Validate its reality by acknowledging it to yourself, either by journalling (see

chapter two), discussing it as a work in progress with someone you trust or, better yet, sharing the milestones along the way (versus the actual end goal) so they might be ratified by others close to you. When you picture something and discuss it in the present tense it will take on a physical appearance and lively quality that will be believable to you and others.

Set some ground rules (here's the discipline part). Do not make yourself vulnerable by sharing your goals with others who might judge you if you don't succeed to their expectations or within their time frame. This is your gig. You play the fiddle the way you want to hear it, not for the audience. You want to succeed; don't be afraid to think bigger than you usually do and perhaps take the risk of doing things differently. There is an old cliché: "If it ain't broke, don't fix it." Well, if you have set goals in the past and not accomplished them, they are broke and they need fixing. You're the only one with the toolbox to fix them.

Take the words *limit* and *boundary* out of your vocabulary. Pretend that you have neither, for truly you don't. We place limitations on ourselves from mislearnings we have beginning as very young children and going right on into our "forevers." Boundaries are obstructions that we buy into because they are visible and thus convincing.

Reduce fear to nothingness. Fear is an amazing detriment. *Feel the Fear and Do It Anyway* by Dr. Susan Jeffers is a phenomenal reference source if you are conservative or unwilling to take risks. It will teach you to transform your passivity into assertiveness. One of my favorite ways to encourage students and employees is to introduce them to their own potentiality for risktaking. There is a thrill to being on the edge, and I'm not necessarily talking extreme sports here. You can be on the

edge in a minute by committing to a goal you've never tried to reach before or by trying any of the other suggestions in this book. Your behavior will take you to unknown places that will show you the door...yours for simply turning the knob.

Goal setting is borderless; it knows no barrier. Powerful lessons, learning your mislearnings and misperceptions after all these years, are yours for the planning, developing and inner satisfaction of knowing you can do it. Realizing goals will guarantee your personal growth, the dawning emergence of your personal creative utopia.

CHAPTER GUIDES

- Goal Number One: Make it a goal to decide on your goals by a certain date on your calendar.

- Determine one of your inherent, individual creative gifts.

- Use that gift to identify your next goal, creating stepping-stones or secondary goals along the way—attainable steps toward achieving the end result.

- Commit to your personal behavior modification.

- Be incessantly altruistic to your inner self when making goals.

- Embrace discipline and structure.

- Get organized; keep a calendar and refer to it several times a day.

- Don't be afraid to think bigger than you usually do.

- Remove the words *limit* and *boundary* from your vocabulary.

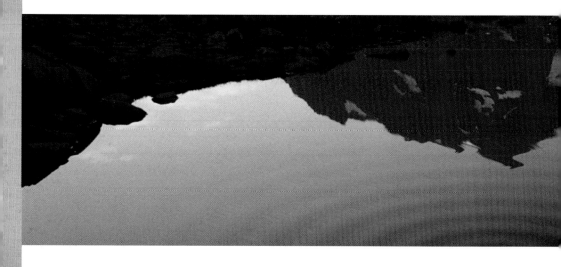

KEEPING A JOURNAL 2

I was twenty-three, in love and moving in with my soon-to-be fiancé. I knew it all. In the basement of my old apartment building, I hurried to purge my belongings. The dumpster outside was totally empty; this would be a piece of cake. I had forgotten about a large unwieldy box that I had stowed away in my assigned storage area. On rediscovering it I was horrified to see that all my diaries, their keys now rusted, my spiral notebooks, old poems, sketches, memories — everything I had so carefully documented from an early age — had become stained and mildewed because of a leaky window nearby.

> Promise yourself you'll burn through, put the real stuff down, and not get in your own way.
>
> —*Natalie Goldberg*, Wild Mind: Living the Writer's Life

Without another thought I heaved the cumbersome box into the dumpster. Daunted for just a second, I peered into the rubble resting at the bottom of the rusted steel cave, which would soon be picked up by a colossal blue truck and carried to the incinerator. I shrugged away the dismay; I simply didn't need the stuff any more. Wrong, oh, so wrong, foolish young girl.

I have regretted that loss for many long years and I have become quite the pack rat, keeping everything containing even an inkling of a penned memory, reflection or inspiration from my past. Erasure is impulsive and the result is immeasurable, irretrievable and unforgivable. Enough said.

There are many ways to keep a journal and doing so will open you to your creative depths, your innermost possibilities. Journals contain memories of people, places, times. If we can tap into those memories, we may find sources of creativity too frequently forgotten because of those mislearnings I mentioned earlier. In our journal writing we can experience a freedom not realized with verbal conversation. All those chattering voices in our head can suddenly become words on paper. They deserve a way out. Good thoughts and bad deserve to escape from our consciousness. The very act of the writing will also awaken subconscious thoughts and allow them to flow freely.

The most difficult thing about keeping a journal is beginning. It takes too much time, someone might find it, all I would do is complain—you know all the excuses. Honestly, I drop and take up the habit of journalling myself for all of the same reasons. In retrospect, my most complete days and time periods have been those during which I have journalled—even if just for a few minutes.

At the very least, make sure you take a journal on any trips you take, whether for business or pleasure. Just a few minutes on a plane or train or in a taxi can provide a momentary escape to describe sensory perceptions, new experiences, emotions, interactions, and so on. The simple act of leaving your home will open your mind to thoughts outside of your norm.

I promise. Pay attention to your thoughts the next time you leave town for any length of time, whether it's for a few hours' drive to an appointment or for a European holiday, unique thoughts will permeate your mind. They are yours for the keeping, *if* you write them down.

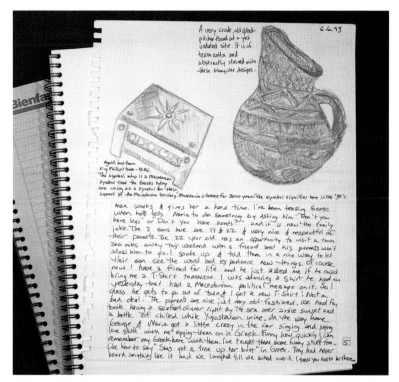

A terracotta pitcher I quickly sketched at the Thessaloniki Archaeological Museum, Thessaloniki, Greece.

Countless times I've told myself, "Oh, I'll remember that, I'll write it down later," only to be distracted "later" and find that I have forgotten the details.

Keeping a journal becomes somewhat addictive. Even if you journal just on Sunday mornings or during trips, the cumulative effort of your documentation will inspire you to do it again and again. Try it soon. Then go back to it a day or two later and marvel at the details you have

already forgotten. The very act will become an irresistible reward for you whenever you are lonely, depressed or uninspired. Because the writings themselves come from a point of inspiration, even if they are indeed to be cathartic and complaining, you control their content and can change their focus at any given moment. This is your gift to yourself and you deserve it.

Again, I will admonish you for thinking a journal needs to be too much or take up considerable time that you do not have. I keep a little spiral notebook in each of my purses and backpacks. It doesn't matter that my writings are not in chronological order and can appear in a green mini-spiral kept in my hiking pouch one day or my leather-bound Kenneth Cole on appointment days. I'm not doing it for anyone else, just me.

I always date my thoughts, but if someone were to ever find them, they would quickly tire of attempting to string them together or make sense of them. On days when I feel bitchy or mournful I might write in code to myself, naming people using initials that often do not match their names. I also abbreviate heavily so that I might more quickly release my darkness. Personally, I am rewarded more significantly when I explore sensations of experience versus documenting an actual event.

Journalling can and should take a multitude of shapes and colors, literally. Experiment with unique ways of archiving your thoughts. Your reward will become opportunities quite frequently, openings of mind and insight that you had never perceived before. Remember to delete the word *limits* from your personal vocabulary and enjoy the outcome.

If you're having difficulty getting started, begin by writing your stream of thought. This can be easier on your computer if you know

how to type. On the other hand, I have many friends who relish the act of putting pencil to paper. With so many digital options available, it becomes quite the nostalgic exercise to find just the right pencil or pen, a writing instrument that frees us for impartial, legitimate expression. Stream-of-thought journalling will be cathartic and relaxing at the same time. Holding things inside inhibits us from moving forward. Let it out, let it go!

One of my favorite journal exercises is to make lists. Especially when I do not have a lot of time, list-making is a great way to express feelings or refresh memories at a later date. I use this method a lot when I am traveling, jet-lagged or tired. An excerpt from one of my "listing" days while on a trip to Provence follows:

Les Antiquities (our hotel)

beautiful English flower garden

cherubs over bed

fabric embossed wallpaper

funny mustachioed check-in man

butt-shaped minitub

John Jacque (an artist we met that day)

superenergetic

very straight, blond, thick hair

blue-green eyes

laugh and laugh, twinkles

so excited to communicate effectively

so in tune to his art

CREATIVE UTOPIA

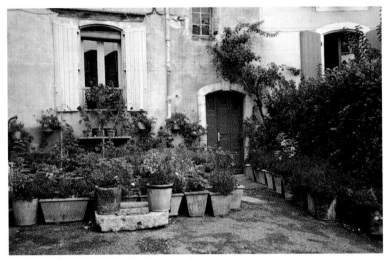

A typical (!) Provencal doorway.

frustrated by a need to price his work

medieval studio bldg.

great logo/adv. art

St. Remy (the town we stayed in)

on a slope

sycamores/buckeyes

windy

fall starting

colorful

great shopping

such a presence of life here

dancing outside in a sixteenth century square

keeping a journal

Dominique and Sophie of Anduz, France.

Dominique (a photographer we met)

quick smile, slight space between front teeth

Skecher shoes

has supreme eye/lighting

worried about his health

excited about his work

fun

Sophie (Dominique's wife)

petite/sweet

ochre kitchen

Idea sketches for a logo and sign design for Rancho La Cuna—La Cuna means "cradle" in Spanish. Below, the finished logo and business card.

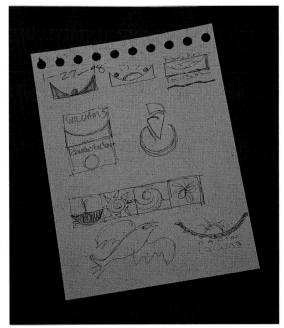

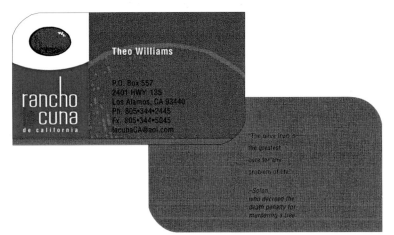

keeping a journal

> great eye for detail
>
> dark eyes and eye makeup
>
> sponge in sink for photo

Note the columns and how just a few lines of description give you a sense of my experience, even though you were not there. Lines that mean nothing to you make sense to me, and that's the whole point about journalling in this manner. List-making is a quick, effective way to journal. It has been several years since this particular trip. Referring to this simple list helps me to recall fine details that I had long since tucked away somewhere else in my brain. I would have absolutely no recollection of most of these details had I not written them down.

Writing out loud is another favorite way for me to record or otherwise diary my experiences. For those of you constantly on the move, this is a perfect way to let it all hang out. You get the benefit of documenting some moments of your time, and when you get the chance to listen to your recording, your self-smiles and realizations will be your just reward. I liken the result to hanging sheets outside to dry—who does that anymore? But remember the sweetness of their smell as soon as you clambered into bed with fresh jammies on? The same analogy prevails.

Analog voice-activated recorders are cheaper than ever because they have been replaced by digital voice-activated models that are compatible with voice recognition software. If you can afford the latter, you will never have an excuse again *not* to journal! Alas, for those of us who still use analog devices (I haven't found a unit compatible with my Macintosh system), it's fun to sit at your desk with lunch or drive to an appointment and listen to yourself go on and on.

Journal pages from a trip to Provence.

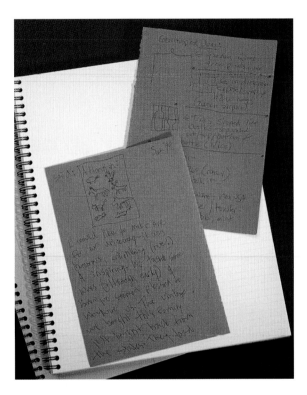

Again, remember to date your recordings. Many times I get great ideas about things while listening to the radio. I am a dedicated fan of National Public Radio (NPR) and find their programming incredibly inspirational. Every time I listen I have a thought I want to remember or hear the name of a book I want to read or an expert on something I'd like to know more about. My handy-dandy recorder is perfect for talking the info directly into the microphone. If it's just information and I'm not too intimidated to share it, I ask my office manager to transcribe it. Does she think I'm weird? Do I care? If it's important and I want to re-

member it, I ask for her help. This process has enabled us to get to know each other, for better or for worse!

If you are still not convinced that keeping a journal of any kind is for you simply because you don't know when or where to begin, try this. Begin now; that's the easy part. Discovering where to start, from a content standpoint, can be overwhelming, especially if you've never done it before. Should you start with a complaint to yourself as in the typical beginning journal? Nothing is right or wrong. But I like to encourage people to start a journal artistically, even if they do not perceive themselves as being particularly creative.

If stream-of-thought writing is difficult for you, try confining your thought to just one concept. For example, think of the color green. Think of everything green you can remember from your childhood, from your last trip to the grocery store or from your immediate environment. Then, adjacent to that list, make another list of words that you quickly associate with the words from your "green" list:

green	association
mom's garden smock	planting seeds with her in spring
lettuce	the salad I made last night
my backpack	climbing the cobbled Corsican village

Do you see where you can go with this small, simple suggestion? Anywhere and everywhere quickly come to your fingertips and open up creative possibilities.

One of my favorite, yet, (alas) empty mini-journals shown here with a pencil for scale.

Another thing I enjoy doing is describing something or someone in as much detail as I can, whether the description is factual or fictitious. Explore your mood as you make up a ghastly character who just happens to mirror everything you are feeling or thinking at the moment. What does she look like? How does she sound? What color is her hair? Her eyes? What is the tone of her voice? What does she say to you right now? Where did she come from? Where is she going? This is one way fiction authors come up with their characters.

Look out the window or take a walk and watch someone, anyone, preferably someone you don't know, walking down the street. Name him. What does he look like? Where is he going? Why is he here? Is he happy? Does he have a family? What kind of pet does he have? What kind of music does he dance to? Make it up; have fun. You can even do

Journal pages from a work-shop I attended.

this journal exercise with a friend. Pick out someone in the crowd and challenge each other to describe everything you can imagine.

These descriptions can be done as a stream of thought, in lists or as voice recordings—it doesn't matter. What does matter is that you do it. Even if you never do anything with it, you will have experienced a different way of thinking that will lead you (and maybe even your part-ner or friend) into a new way of self-expression and self-awareness.

Reading other people's journals or diaries can awaken us to many of our own creative aspirations. Many well-known authors and celebrities

My favorite sketch journalist of all time, Sara Midda. The cover and two inside spreads are from Midda's *South of France.* **Notice her fluidity and how effortless these seemingly simple, yet dynamic illustrations represent detail and even emotion.**

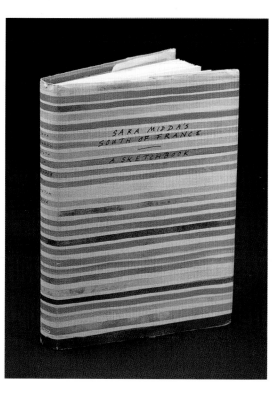

publish their memoirs usually later in their lives, the theory being, the longer the life, the richer the details. Countless titles abound, and I have a few of my favorites included in the resource section of this book. Some of them are rather obscure; all of them have taught me more than one thing about myself.

Natalie Goldberg, perhaps best known for her books on writing, *Writing Down the Bones: Freeing the Writer Within* and *Wild Mind: Living the Writer's Life,* published a beautiful book entitled *Living Color: A Writer Paints Her World* that pairs autobiographical essays and paintings.

keeping a journal

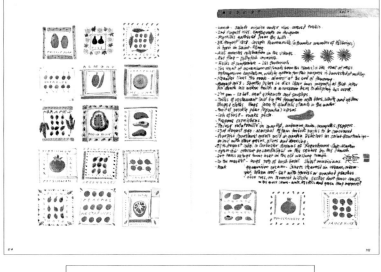

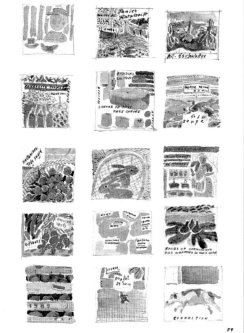

"Known for her books about writing, Goldberg once used painting as others do a walk in the woods or a martini before dinner—as a way to unwind. Fearing dilettantism, she quit painting altogether only to find that when she stopped painting, 'I gave up a deep source of my writing, that place in me where I can let my work flow.' Once again she embraced visual expression, which she realized she had used 'as a metaphor or mirror to break out of something I didn't understand in writing.' The paintings have a colorful, folksy feel; the book is an interesting exploration of the influences that the various aspects of our lives have on our work and vice versa."[1]

Perhaps you have seen sketches by John Lennon or been surprised to learn that Clint Eastwood is a painter. We have all been surprised by the person we least expected to be creative showing up with some incredible homemade thing. These people are simply projecting their creativity, voicing their art to realize a release, ultimately utopian for them in some way, shape or form.

Check out the color plates of sketches from various journals throughout this chapter. Mine are more accurately described as scratches! But it doesn't matter, as long as they help me to remember what I am trying to convey. Beautiful sketchbooks get published and it is great fun to live vicariously through them as though visiting the photo album of another's exotic trip.

Start your own sketch journal and enjoy the results, even if you never share them with friends. Most of us greatly enjoyed art when we were

[1] Editorial review of *Living Color: A Writer Paints Her World*. Can be found on www. amazon.com/exec/obidos/tg/stores/detail/books/0553354892/reviews/ref=pm_dp_ln_b_6/104-9296850-8976724

keeping a journal

very young. It was only when we got older and our art classes turned into competitions for grades and teacher accolades that we closed our Crayola boxes and retreated to a safer place.

Keeping a journal may seem too much like work. That is why it's important to find a medium that works for you. Too many times we are hiding behind our memoirs, our experiences, our deepest thoughts. Journalling gives you a snapshot of various times in your life. Realizing emergence through self-expression in our journals will enhance our freedom and bring a new sense of inspiration. If you can realize this nourishment via your journal-writing you are embarking on the steps to creative utopia.

CHAPTER GUIDES

- Use your memories to tap into creativity.

- The hardest thing about keeping a journal is beginning. Start now.

- Don't try to control your writing or be too strict about maintaining chronological order but do date your work.

- Keep notebooks—large and small—handy at all times, in all backpacks, car consoles, fanny packs, backpacks, purses, briefcases, etc.

- If you have trouble getting started, begin by writing down your stream of thought.

- Try different ways of journalling; making lists, for example.

- Write out loud; get a voice-activated recorder and talk on!

- Try a sketch journal.

BECOMING WIRELESS
IN A WIREFUL SOCIETY

3

The statement from *Wired,*

shown above, is just one of millions of examples showing the very founda-
tion of our society changing dramatically as technology dominates every as-
pect of how we communicate, how we are entertained and perhaps most
importantly the content based on which we are influenced to make decisions.

One-quarter of Americans were considered obese in 1980, one-third in
1991 and by the late 1990s 74 percent of Americans exceeded the maxi-
mum suggested weight for their age and height category.[1] I find it fasci-
nating that between 1980 and 1991, when the PC began its invasion of
American homesteads, a startling rise in many chronic symptoms and ill-
nesses began to occur.[2] We have impressed the world as we have grown

Copycats like MyNapster, OpenNap, and CrackNap—
which quickly reverse-engineered Napster's peer-to-
peer protocol—have set up more than 700 alternative
servers planetwide.

—*Stuart Luman and Jason Cook,* **Wired,** *January 2001*

into a nation of high-tech solutions where practically everything is resolved
through some type of digital mastery in our factories, hospitals, schools
and homes. Ironically, however unsubstantiated scientifically, it seems the
people of our nation have traded their health for a wealth of buttons on
machines perfoming an infinite number of personal and professional tasks.

Don't get me wrong; I'm not down on computers. I love all three of mine!
But over the years of owning and working with them as a creative person
I have also come to see their detriment. So let us hearby resolve to occa-
sionally take a vacation from the electronic madness. Simply stop. Take a
lucid moment to explore the theme of "back to basics." This chapter will
show you how and why.

Every morning at six my favorite CD of the moment receives its laser and gently awakens Joel, me and Maxine, our German shepherd who insists on snoring at the base of our bed until she hears the music. We're all programmed. When the music starts the day begins. The automatically programmed coffeemaker begins to brew its heavenly revival liquid. The television will be turning on in exactly nineteen minutes to offer the local weather report. My cell phone will soon be "prrringing" with today's calendar reminders; the girls' Barbie radio will soon be playing this week's teen idol morning hit, reminding us all to call in when we hear the song of the day to win a family trip to Walt Disney World.

The first thing I do, before everyone gets up and running, is to pad barefoot into my office and check my e-mail. I'm not certain when this dreadful habit began. After all, many of my Real Art clients or staff, Global Gardens customers, my publishers and family are all on Eastern Standard Time. I'd hate to be behind the eight ball on any important information someone might be trying to get to me. It only takes twenty to thirty minutes for me to check everything out and be on top of things before the day *really* begins.

Last year Joel and I took a trip to the island of Crete to do some business and visit our favorite isolated spot, Porto Loutro, accessible only via a ferry ride from a somewhat larger but still very obscure port at the southern tip of the island. We stayed for a week. No cars, no radio sig-

[1] Fumento, Michael and Manson, Joann E., 1998, *The Fat of the Land: Our Health Crisis and How Overweight Americans Can Help Themselves*, Viking, NY.
[2] Sarno, John E., M.D., 1999, *The Mind Body Prescription: Healing the Body, Healing the Pain*, Warner Books.

nals and, alas, no computers! A funny thing happened. My mind was free. Free to see colors, hear sounds, taste flavors that before were shrouded by the color calibration of my monitor, the download speed of my MP3 player or the absence of any savory characteristics at all because of my preoccupation with my e-mails while I'm munching my morning nutrition.

I vowed to change. Back home, my vows were quickly forgotten; true habits die hard. Then it happened. On January 2 of this year, I quite innocently began a new routine, having no idea what a profound experience it would be for me and my family. Over the holiday season I had read *Ancient Secret of the Fountain of Youth* by Peter Kelder. The book is a very light read, and I had picked it up quite casually while waiting for Joel on a day when (ironies abound—check out chapter nine) the digital readouts on my car were out and we were forced to double up in our only functioning vehicle to do our errand running.

The book explains five yoga-style exercises supposedly performed by Tibetans who live to be so old that nobody knows exactly how old they are (they don't have computers to store the data!). My new routine has opened my mind to a clarity I had never believed would exist for me in the morning, lasting all day. I have never been a morning person; Mom used to totally aggravate me with her "Good morning, sunshine" rhetoric because I knew she was making fun of me as I grunted my way through nineteen years' worth of mornings with her.

Quite by accident I have transformed not only my morning but my entire day with an unplugged experience that starts my creative juices flowing… and I'm finding much healthier results, inside and out. A series of five positions, each done twenty-one times, only takes about

twenty minutes. The resulting energy gives me much more than that amount of quality time during my day. Just like with journalling, I might use the excuse that I don't have the time to perform this routine. But when I look at my increased productivity and clear mind so early in the morning, there is unquestionably no trade-off.

I telephoned my mom at 7:00 a.m. the other day, having performed the exercises and feeling like talking. Needless to say, she was impressed that after forty-one years, her "sunshine" was finally shining in the morning.

Everything in our lives today revolves around being plugged into something. Computers dominate our every movement. If we are going to find true creativity we need to seek out methods that will release us from electronic paradigms. If we cannot achieve personal balance we will cheat ourselves of our creative present moments, our self-awareness. It is so easy to become merely reactive to the plethora of information that bombards us, begging for interaction and transmission of some sort.

Alternative methods of becoming "wireless," at least temporarily, are represented in nearly every section of this book. But purposeful intent to do so is required if you are finding yourself plagued as I described myself at the beginning of this chapter. Your success in finding the treasure of your own creative utopia will depend greatly on how perceptive you are about your actual current conditions and environment.

If you haven't a clue as to your wireful versus wireless tendencies it's probably because you have become completely accustomed to being reactive. It takes a perceived substantial amount of time to make changes in our behavior, better left for another day (translate: another

lifetime). Or better yet, let someone else do it so I can live vicariously. But just as in learning to journal, you don't have to commit to doing it daily, just once in a while. It's not realistic in our frenzied daily lives to think that we can totally change habits that just feel good for whatever reason. But we can slip in new things here and there for an occasional change from the typical. The result will be an emergence of your creative inner self.

Try aromatherapy. Experimenting with this healing art is nothing new. Millennia-old Egyptian tombs cradle vessels of essential oils presumably used to heal the sick. Frankincense and myrrh are said to have been taken as gifts to Bethlehem; the Bible refers to them frequently in association to wellness. Aromatherapy can be used to create a mood, evoke a certain memory, rejuvenate the mind or relax a tired muscle, including our brain.

What do you think of when you smell a rose? Or cedarwood? Cloves? Pine needles? Cinnamon? Lemon? Aromatherapy arouses tired sensory perceptions, enticing our brains to remember an association with a certain smell. So whenever you get a whiff of a certain smell, you almost always return to a specific memory. It's like when certain songs on the radio immediately take us back to a special moment, place or time in our lives.

Aromatherapy is one of those words that connotes a sense of esoterica or femininity. But don't be fooled by that fallacy. Monks in the Middle Ages can be given credit for distilling herbs and practicing with their special properties, resulting in many pleasing discoveries. The distilling process of specific herbs and plants results in what is called an essential oil, pure and undiluted with any other carrier oil or substance.

Essential oils can be found at any reputable health food store along with pamphlets on how to use them and, specifically, what herb to use for a precise result of whatever type you might be looking for: energy, relaxation, clarity of mind—the list of probable effects is generous. Many hair salons and also many drugstores are beginning to carry essential oils. Try to find pure oils instead of blends so that you can realize the powerful attributes of these natural enhancements.

Aromatic baths aren't just for ladies, gentlemen! My husband revels occasionally in a cleansing bath of eucalyptus salts that simultaneously refresh, uplift, invigorate and clarify his senses after a tough day. Aromatherapy massage allows the the essential oils to penetrate directly into the bloodstream delivering whatever benefit the chosen herb or plant offers. How many times have you been forced to retire early, passing out from utter fatigue after a stressful day? Knowing what plants to use to change your days for the better can help you climb another rung on the ladder that leads to creative utopianism.

A little research is required for aromatherapeutic success. As I mentioned earlier, the store where you buy the essential oils should have a brochure describing their properties and effects. People who have certain medical problems, are pregnant or are taking specific medications are warned to observe precautions with some essential oils. But researching aromatherapy qualities is very easy as many more people on a quest for creativity seek out alternative methods for personal quintessence. In Europe, aromatherapy is very commonplace.

Henry David Thoreau proclaims, "If the day and night are such that you greet them with joy and life emits a fragrance like flowers and sweet scented herbs—that is your success. All nature is your congratulations."

Thoreau's sweet assembly of words leads me to another suggestion for unplugging yourself at any given moment. Again, it can just take a few minutes to try this. A change in perspective can awaken many things in such a short time. I call my next action project toward reaching some creative reparation "awareness walking."

We walk from our cars to the bars, to our office, to the school, to the grocery, to see our friends. So why not walk with a purpose? You can try this a million different ways of your own benevolence, using my suggestions as a starting point. For example, your first time out, look for reflective light as you walk. Even if you're not a painter or a photographer, you know what reflections are, right? Look for them, study them, see only them.

If you have but a few spare seconds, whip out your notebook and journal what you see. Quite frequently I'll be walking with my girls, my husband or a friend and stop to point out and remark on certain reflections that I see. So you can do this visual activity even while you are engaged in conversation. This simple technique will take you as far away from your computer keyboard and Palm Pilot as you want to go. Turn off your cell for a few minutes while you enjoy this simple act of creative attentiveness.

Your newfound consciousness can take you on another walk where you look for only one color in everything you see. For example, take the color blue. Even if the sky is cloudy you can choose blues almost everywhere; there will surely be blue cars, blue awnings, blue typography on billboards, blue clothes, blue circles under people's eyes. Blue abounds. So does green, or red, or brown—every color you can name is there for your selective viewing.

This natural rock forma-
tion on the island of
Santorini resulted in my
seeing some incredible
imagery upon closer ob-
servation.

becoming wireless in a wireful society

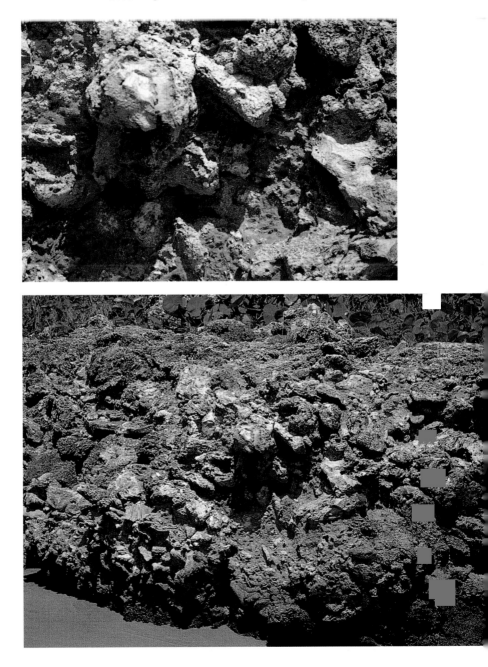

By training yourself for just a few minutes at a time to see certain colors selectively, you can begin to put yourself in a disciplined frame of mind that ingeniously uncovers new information. It's always there for the taking. You must simply change your frame of reference or application.

You can do the same walking visualization looking for certain textures or shapes. Colors, textures and shapes have obvious creative applications; this is a wonderful exercise to do with children because it makes them more observant and appreciative of their conscious environment. Children respond exceedingly well when you make this endeavor a game, especially while you are driving. Challenge them to keep track of who can see the most of any given subject. They will probably surprise you by seeing more than you do. Our adult eyes are trained to see things a certain way. This exercise will take you back to ways of seeing that you may have forgotten long ago.

Whatever your method for unplugging yourself, try to do it for at least a few minutes every day. When you take a vacation, take a vacation from your computer too and from your cell phone and anything that resembles an LED readout. Trust me, if you want to realize creative utopia in any way, shape or form, you need to have an appreciation for making the ordinary extraordinary somehow.

becoming wireless in a wireful society

CHAPTER GUIDES

- Commit to unplugging yourself once in a while. Know that this is a reward, not a punishment.

- Experiment with aromatherapy.

- Go for a walk with the intent of being aware of something. For example, study only reflective light, look for only one color at a time, journal what you see.

- Go ahead, turn your cell phone off for a few minutes!

- Unplug for at least a few minutes every day.

- When you go on vacation, take a vacation from all wired and wireless objects that perpetuate your connectivity.

CREATIVE UTOPIA

FENG SHUI

4

My good friend Sue Jackson first introduced feng shui (pronounced *fung schway*) to me about ten years ago when I was living in Ohio. "Fing wha?" I remember saying, trying to make a joke, thinking this must be another one of Sue's psychic, off-the-wall ideas. Shortly after she told me about it I began hearing little blips about it here and there and then, suddenly, everywhere. When it was mentioned on the ever-respected National Public Radio (NPR) network, my favorite source for news and entertainment, I decided I had better learn more. I was truly way behind (thousands of years!) the times.

Feng shui is an ancient philosophy of Chinese origin that has its foundations in Taoism (pronounced *Daowism*). Historically, Tao is most often seen in translation as meaning "the way." It is not a tangible thing or place; rather, it is beyond time and space. It underlies reality and cannot be described in a literal fashion. Taoism is observed as a religion in Taiwan, Hong

> It is often said that the only constant in life is change!
> —*Sally Fretwell,* **Feng Shui: Back to Balance**

Kong and many areas of mainland China. The most ancient form of the Tao represented the emptiness and stillness from which the forces yin and yang transpired. These complementary forces explained the differences between seasons, genders and other shifting patterns that eventually come into balance. The Tao itself is said to be a constant from which everything is derived.

This chapter will teach you some very basic theories on the art of feng shui. It is not acknowledged in the West as a science because its principles have not been proven by any accepted scientific method. The most basic premise of the underlying philosophy of feng shui is that you must live in total harmony with your environment so that the surrounding energy works with and for you instead of against you. It is always easier to walk with the wind at your back, swim with the tide and look in the direction that the sun is shining.

The words *feng* and *shui* translate from Chinese as meaning *wind* and *water*, both elements of our natural environment of which we are well aware. These natural elements connect us with the earth, our bodies containing mostly water, the wind being something we might equate with breathing, oxygen, life force. The ancient Chinese philosophy of feng shui dates back over six thousand years although the actual discipline was not relevant until a mere three thousand years ago. Most recently, and sadly, it has lost its original imperative status in China because of Communism, which downgrades the art to what is perceived as an antiquated feudal system. As contemporary Eastern cities like Hong Kong strive to emulate their Western competitors, the primary function of feng shui in Tokyo life, for example, has been reduced to modifying business environments. I guess they didn't want to take the risk of losing profitability by eliminating it altogether.

Feng shui can be viewed as a discipline, but it is actually very personal. It does not dictate aesthetic standards; it simply acknowledges basic attributes of our environment that might offer positive impact in our lives. We choose the textures, the colors, the patterns. It is important to acknowledge our personal subculture or ethnic heritage within our surroundings, which makes the application of the feng shui principles particularly individualistic, and an amusing opportunity for creative self-expression!

There are many forms of thinking regarding the physical aspect of feng shui that are called schools, like schools of thought. Each school builds its philosophy on different interpretations and applied tools that appropriately connect people within their innate desire for balance and

feng shui

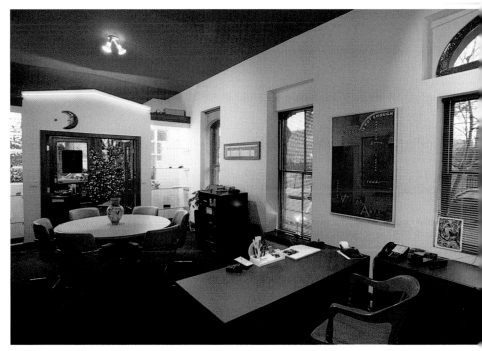

My Real Art office in the early 90s. Feng Shui perfect, unbeknownst to me at the time! Good fortune prevailed.

harmony. The two traditional schools of feng shui are the form school, focusing on the shapes of objects in our physical environs, and the compass school, which is more analytical, representing environmental areas with concentric circles measured by a magnetic needle. The pyramid school is now the most common and contemporary application of feng shui, especially in the West. This school acknowledges the foundation of the original theories, combining them with modern discoveries in psychology, space planning, biology and the ascendancy of our senses.

The basic components of feng shui go together like ingredients in a homemade cake. If one is left out, the result can sometimes be OK, but it is apparent that something is missing. Tao is referred to as an

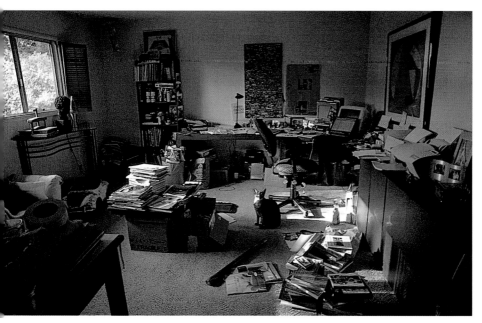

A real feng shui nightmare. Even the cat looks dumbfounded! I am embarrassed to admit that this was my first home office at our fixer-upper ranch. It is currently undergoing massive transformation since researching and applying feng shui to my life.

element of feng shui to be used as a connecting factor, in an applied sense, to connect the indoors to the outdoors somehow, to connect the rooms of a space via color, style—some type of common thread. Yin and yang literally are opposites but in this case they suggest a balance of opposites, light to dark, curves to straight lines, low areas to high, etc. An equally important aspect of feng shui is *chi*, representing energy, vitality. This quality directly relates to flow within an environment.

The five significant elements of feng shui are fire, earth, wood, metal and water. When one takes these words at their literal meaning the association becomes difficult. Instead, think of fire as warmth, earth as supplying nutrients, wood as taking in the nutrients but growing into

feng shui

a strong tree useful for many things, metal as a conductor and water as a fluid, mercurial element or shape. It is important to identify the correlation of these elements within our surroundings and make sure they are not competing with one another but are properly enhancing one another. Each of these elements should act as an expressive, natural conduit to the others. Further study on the elements is suggested for maximum positive performance.

Acknowledging your intuition plays a very important role in the theory and practice of feng shui. Sally Fretwell, in her wonderful book *Feng Shui: Back to Balance,* offers the following analogies, which synthesize intuition to our physical space and their relevance to the successful practice of feng shui:

"Whether you realize it or not, your intuition is at work at all times. Your senses receive information about your environment—tasting, seeing, touching, hearing and smelling. Your mind computes facts and labels them for referencing. The impressions you receive affect you both consciously and unconsciously. Everything is filtered through your personal perspective."

Sally describes an experiment she often conducts at her workshops where she gives out colored pieces of paper to part of the audience after they have closed their eyes and asks them to share what they feel from the color, eyes still closed. A woman holding a sheet of yellow paper exclaimed that she felt sunshine, while a man said the piece of paper he was holding reminded him of going sailing; it was blue. She does this exercise to illustrate one of the most basic principles of feng shui: "Your body, spirit and emotions respond to unarticulated impressions from your environment... every object holds a vibration with which you

CREATIVE UTOPIA

interact. Your body and energetic field register everything you come in contact with—whether you are conscious of it or not. Although feng shui offers guidelines to assist in balancing yourself and your environment, it is up to you to trust your intuition and put the non-mental aspects of feng shui to practice Feng shui is about making you feel comfortable, supported, rejuvenated and at peace."

A few fundamental applications of feng shui follow:

1) Clear away all clutter. An array of unfinished tasks, unfiled papers or unpacked boxes crowds the mind and any creative productivity. If your eyes cannot see it, you will be much more calm and open to thinking freely. Keep only one project at a time on your desk.

2) Never face a corner or a wall. Face outdoors whenever possible, so that at least your peripheral vision receives natural light. Windows at your back will lessen your authority and squelch your ideas, your productivity.

3) Add plants, grouping them in threes, whenever possible. Green helps cash flow, encourages profitability and inspires growth.

4) Arrange the furniture in your space so that the flow is free; you can walk around everything.

5) Use wind chimes outdoors where you can hear them occasionally to attract strong, healthful chi.

6) Choose artwork and accessories for your office that appeal to you personally, bringing a sense of joy and promoting happiness. Do not use dark wall hangings or pictures showing despair or stress of any kind.

7) Fish, birds, fountains—either real or in figurine—are symbolic reminders of luck, prosperity, nature and the joy we can find there.

feng shui

Acknowledging the actuality of feng shui has greatly affected my life, but it's also easy to forget about. I spent a couple hours with my architect friend Chuck laying out my new warehouse/office space before a recent Global Gardens move to a new office. It all looked perfect on paper. Grass roots though it is, we chose some nice utilitarian furniture from IKEA and designed the 17' x 19' space with visual balance and geometric perfection. My only initial (and intuitive) reticence was that I was not facing the front door comfortably, but from a catty-corner vantage point. Chuck was quick to point out that I was facing the skylight and plenty of natural light would swathe my desk. Logically, I agreed.

The first day in the office I felt horribly uncomfortable. I spent most of the day working on the long, flat planning portion of my desk, not at the elbow portion of the table designed for my computer. My back was squarely to the door. I was looking at about fifty-six palettes of product that represented my entire life's savings, my retirement. When and how was I ever going to sell this stuff? Anxiety abounded. An underlying sense of nervousness, uneasiness and self-doubt plagued me. On top of all this, it was my new office manager's first day; she and I were trying to become acquainted. To redirect my attitude I suggested a nice lunch, outside, taking in some sunshine; this was California, after all!

When we got back from lunch I said, "You know, this desk configuration is just not working for me." Deborah leapt at the opportunity, "It's not feng shui, you know. We need plants, more color, you need to face the outdoors, we need to make this space speak to profitability!" I knew she was right. All I could think about was spending yet more money on plants, colorful accessories, artwork... auuuuggggghhh!!! Immediately we began to tug and pull at the long heavy desks, changing the direction of the car-

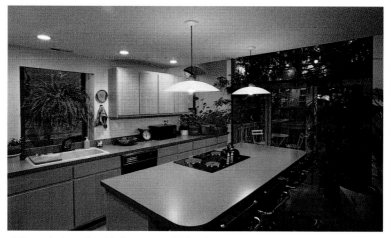

A feng shui perfect kitchen...nourishing body and mind. Notice the plants, windows, sink and island placement.

pets underneath them, heaving, panting, opening the door in an effort to cool us in a space that had seemed quite chilly during our sedentary morning tasks. I felt bad; it was her first day and I was bossing her already ("it would be easier if we did it this way"). But I quickly became impressed with how she took it a step further and knew exactly what was in my mind. We didn't have a lot of options from a feng shui perspective.

Ironically, as soon as we changed the configuration, my outlook improved. I had a major view of the sunny outdoors, flowers blooming, hummingbirds feeding. The phone rang with a nice retail order. My new broker called to tell me that he would be faxing several nice wholesale orders soon. Deborah and I validated our sore backs the rest of the afternoon because we simply felt better. I immediately went out to buy some nice plants and a fish bowl, designed a colorful mobile for the space and added some graphics to the walls.

I highly recommend more concentrated reading on feng shui, discovering your personal kua number and the Eight Aspirational loca-

tions for eating, sleeping, working and creating that are auspicious for you as an individual. I have only given you the very basics. The philosophy deserves a lot more attention, especially from those of us who endeavor to be creative. It promises to enhance our spaces beyond the quintessential aesthetics we strive to achieve, focusing more on the experiences we realize by inhabiting our surroundings. After all, who doesn't feel better after eliminating clutter and adding some color to their lives? Creative utopia is one step nearer when we use feng shui to establish balance and harmony within our work and home environments. I am personal, living proof of this!

CHAPTER GUIDES

- Acknowledge your intuition about your physical space and environment.

- Clear away all superfluous clutter.

- Never face a corner or a wall.

- Have plants, grouping them in threes or fives whenever possible.

- Arrange furniture so that a nice flow exists in and around it.

- Hang wind chimes.

- Choose artwork and accessories that specifically appeal to you.

- Try to include fish, birds, fountains or their sounds into your space.

MAKING YOUR OWN MANDALA 5

The purpose of my first trip to Nepal in 1999 was to meet the little girls who would become our adopted daughters. The gentle, smiling people of Nepal, the cacophony of smells, the clatter of traffic and bodies smashed together along the sides of the roads desperately trying to avoid being run over by a rickshaw, a truck, a sacred cow—none of the wild obliteration of senses could prepare me for the rush of enthrallment I experienced upon being introduced to the art of the mandala. I was in a thangka gallery when a piece of what I considered to be great graphic design and inspiring use of color caught my eye. I had to have it.

Why is the piece unsigned? Who created this piece? Did they use a tool to create the perfect, concentric circles? What does it mean? Gauri smiled at me and shrugged his shoulders in the spirited, carefree manner typical of his people. "All I can tell you is that it was created by a Tibetan monk. They do not sign their work. To sign a piece of artwork is unsacred in Tibetan culture; it removes their inner spirit. It was created with a single-haired brush, all done by hand, and it simply means *om*. The surrounding art is representative of the cosmic world in which the artist is finding himself, with the other symbols mantras of his inner being. But this is not a very good mandala, sister. It is too simple."

The reverse side also has a reverse side.

—*Japanese Proverb*

He wrapped up two more elaborate mandalas, painted with gold leaf and Buddhist deities, that are truly beautiful, but do not speak to me personally as vigorously as this one does. This is the very art of a mandala, the personal meaning and significance that one depicts with images, first beginning with the center area—the heart of the art—then building around it until it is finished in one's mind, signifying an overall theme or relevant message.

When I returned home from my trip, jet-lagged and unable to sleep because of the dramatic change not only in the time but also my environment, my experience with such a unique third world culture, the prospect of motherhood and a totally new perspective on creativity, I wrote the outline for this book. Two days after returning to the U.S. I faxed the entire proposal including detailed silhouettes for each chapter; everything was so clear in my often turbulent mind. I credit my lucidity then with my realization that I had aggregated a fairly cohesive collection of thoughts I wanted to share with others aspiring to reach a creative utopia. The psychology behind the art of creating a mandala—and each individual finished mandala itself—is a utopian work of self-expression.

A colossal, profound thanks goes to Paul Heussenstamm who let me invade his mandala studio for a generous amount of time, enlightening and inspiring this entire chapter.

Mandala is a Tibetan word for wheel and in the physical art form represents the circle of a belief, an awareness, an innermost expression from the heart. A mandala can guide one toward self-realization and introspective self-therapy beyond any other art form. It becomes a self-teacher, offering messages and enlightenment. Creating a mandala allows artists to get in touch with their own mysteries, their own deep beliefs. The art comes from the personal and realizes the transpersonal, a tremendously powerful exercise.

Ancient Buddhism shows us mandalas made of sand, which is still a popular material today, representing mandala art in many Buddhist communities. Sand mandalas are used to teach that time itself is impermanent; the present moment is very delicate, very beautiful; we must capture it right now. I have seen many sand mandalas in Buddhist temples in various parts of Nepal, Bhutan and Thailand. They capture an essence of fragility, the virtue of time, while telling a story of paradigms and continuity.

In Tibetan culture everything has meaning, everything has great value. Words like synchronicity and coincidence do not exist there. Adjectives are collective; there are no personal pronouns. The mandala reveals a participation within the artist of his personal awakening, feelings, transformation. Mandalas are created as a visual transformation of beliefs, and for no other reason.

The Dalai Lama recognized a world that was in great need of healing when, in the late 1980s, he revealed to the world many sacred Buddhist mandalas that had previously been viewed only by traditional practitioners. The mandala as an art form then became a popular sub-

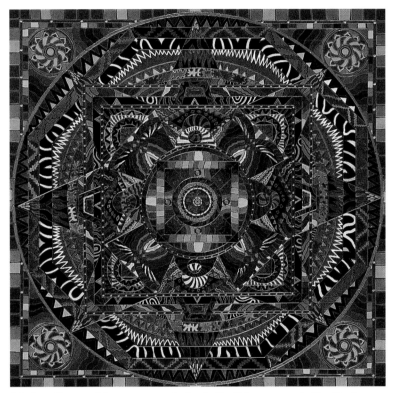

My favorite mandalas are more abstract, like this one, created by Paul Heussenstamm. I like to use the center point on a mandala like this as a meditational focus.

ject of lectures in colleges, museums and study groups. These ancient works, which had been hidden for thousands of years, once exposed in the West inspired many artists and therapists to begin creating mandalas to develop renewed attentiveness.

Paul Heussenstamm was a graduate of a well-known art school and a successful fashion designer, partnering in business relationships that

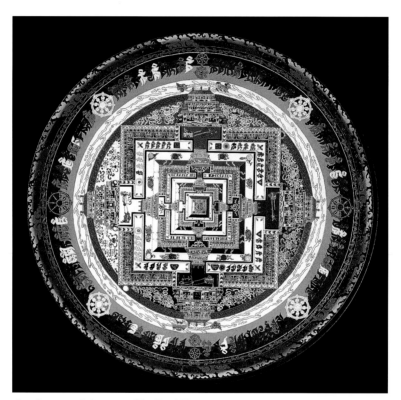

Another mandala created by Paul Heussenstamm.

sustained him very well. He made the "mistake" of going to pick up his children from an art program they were taking on Thursdays; his wife at that time normally performed this duty, but on this particular day it was his turn. He says that he walked into this room of children painting, the smells and colors just "blew him away," and he asked the teacher if he could join his children in painting every Thursday. He insists, "I didn't find art; art found me." He began to get excited about some of the

making your own mandala

things he had loved as a child, added Thursdays to his weekly itinerary away from his "real job," and for over ten years now has been painting full time. There's a year wait on his commission list.

"A mandala is a wonderful practice for taking people away from their own self-control, which is the enemy of creative art. I can do this, I can't do that, I'm not talented. It is mind thinking, and the mandala is just heaven to get away from that place and into your own unconscious because you are constantly going around in a circle; so it's a wonderful practice of getting people out of themselves." Paul made these profound comments before he explained how anyone can make his or her own mandala.

Paul starts his mandala workshops by emphasizing the importance of ritual. Meditation, yoga, anything that can open his students to self-realization is encouraged. Paul says, "One of the things they don't teach in college is ritual and all of the good artists I know have rituals." Many times he guides students into ritual by playing very loud music—rock and roll, chanting, whatever—leading to an aroused, focused, concentrated effort to be reflective.

The next step required, after ritual, is to make a list that expresses your core values. This is a visual list, not a written list. Even if you are capable of drawing only stick figures at first, do that. Once the list of symbols important to your "wheel of life" is completed, your next step is to do a rough sketch. This is accomplished without concentrating at all on the physicality of what you are doing. There is no right or wrong as you sketch a mandala without any self-control.

Your sketch complete, you might start thinking about your specific symbols in a circular pattern. Many people have great difficulty finding

Paul works mostly standing over his mandala creations. He works with amazing speed and accuracy, totally connected to his productivity.

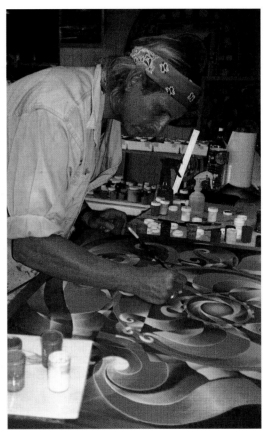

the center of a piece of paper. I was astounded to make this discovery in several community college courses I taught years ago, and Paul shared his bewilderment with this consistent occurrence in his workshops. He believes this to be symbolic of people not being able to find their own centers and is quick to allow that, at the end of his mandala sessions, all the participants easily realize the center.

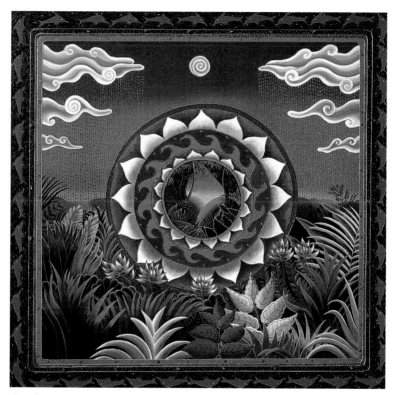

Another mandala created by Paul Heussenstamm.

Next you create the diagonals while paying attention to the radius and the concept of the integration of the male and the female, the yin and the yang. The circle represents your female side, while the square, identified by the diagonals, represents the male. We each have feminine and masculine qualities no matter what our gender. Next we begin to perceive the vertical axis of the mandala, the male, and the horizontal, representing the female.

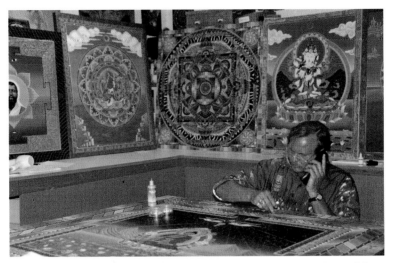

Paul doing "business" on the phone while filling in his sketched mandala with one of the plethora of colors he uses to express his art.

The symbol in the very center of your final mandala sketch should be of that which is closest to your heart. Things that are extraneous can be placed at the farthermost area outside of the circle, emanating from the nucleus. Significance should be placed on the symbols representing male and female thinking within the vertical and horizontal elements of the composition. Geometry naturally begins to take form and function within this final sketch as you develop the significance of your composition.

Choosing color and beginning the final painting of your mandala happens after you transfer your sketch to canvas, masonite or whichever substrate you have selected for the final version. It is important while choosing color that you stay focused on opening your heart instead of your mind. The natural discipline of the mandala, forming a circle that you build from, allows you to escape in timelessness, taking you to a

making your own mandala

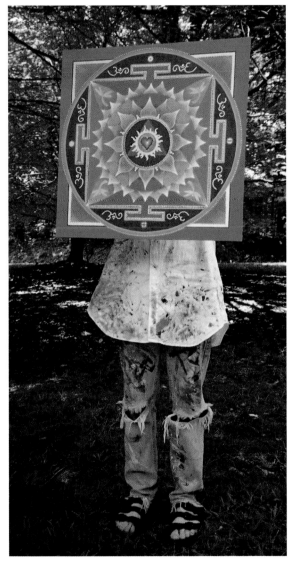

This woman poses with her mandala smiling back at the camera. She had never painted anything before, is not an "artist." This is her first attempt at creativity!

new realm of creativity. Let the colors pick you. It will lead you to places where you have never been but now can go naturally. It is best in the beginning to do a mandala with a group so that you maintain the quality of not thinking too hard. Music, the outdoors, anything that creates an environment of free-spiritedness enhances mandala art.

Mandala art can widen our perspectives and throws out many old opinions of the self. Everyone can become a mandala artist when they find a place inside of them that is expressive. Paul analogizes doing mandalas to having a TV with a hundred different channels; the mandala is the same thing. Go to your own heart and open up the channels. The mandala teaching helps us to understand that there is nothing new to really learn about the creative process itself, but it raises a question: How can we tap into it? It is not necessarily about talent but about being present and aware. It exposes what we already know but have put away because of mislearnings, constraints we place on ourselves or perceptions we own for whatever reasons.

Being provoked, intentionally, to introspect, results in a very positive outcome for the mandala painter. Expecting the unexpected—transformation—has resulted in 100 percent success for Paul's students. In the history of Paul's workshops no one—not even students who have never held a paintbrush in their hands—has failed to complete a beautiful mandala. (See pg. 81 for a picture of a student who had never painted before and the radiant mandala before her.)

As in so many other disciplines shared in this book, the art of mandala painting is a stepping-stone to many discoveries about yourself. The only way to achieve creative utopia is to accept every semblance of our artistic selves without judgment, no rights, no wrongs. A man-

making your own mandala

dala can be a visual reminder to us in our hurried worlds that time-lessness does exist if we make a place for it. Creativity is there if we are open to being aware of it. Utopia is ours for the creating!

CHAPTER GUIDES

- Be determined to get away from your own self-control, to explore freely.

- Begin with a ritual of some type—yoga, music, chanting, meditating, etc.

- Make a list that expresses your personal core values.

- Do a rough sketch of this list.

- Think about your sketched items in terms of a circular pattern, creating a hierarchy with the most intimate subject in the very center and working out to the more superficial subjects.

- Get in touch with the female and male interpretations of your core values.

- Stay focused on opening your heart while doing the final sketch and choosing colors to paint.

- Be ready to throw away old opinions of your self.

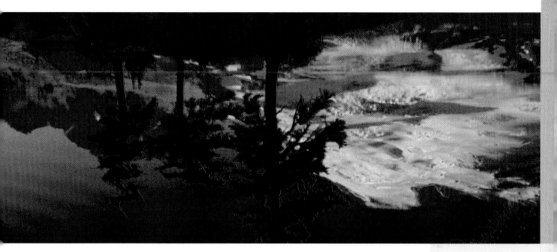

THINKING OUT OF THE
PROVERBIAL BOX

6

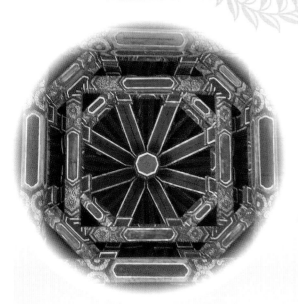

Our lives are in a literal state of con-
stant transformation. No two days are ever the same. We can plan our
little hearts out and have those Palm Pilots all organized to the max with
birthday and meeting reminders, e-mail addresses, your favorite uncle's
shoe size—it doesn't matter. Things arise every day for which we had no
plan; we ask, why or, why me? There is no conceivable reason in many in-
stances, yet we spend countless hours of precious energy in futile effort,
trying to make the discoveries. Overnight our bodies change in minute pro-
portions until we wake up ten years later and say (about our neighbor),
"Gosh, she's really looking older since I saw her last," as though we were
supposed to stay the same!

Most of us picture ourselves staying the way we were when we were, say,
twenty-eight, but we can ultimately agree that no one ever really accom-
plishes that feat. So what, then, can we expect from our creative selves? If
we are truly going to excel creatively we must consciously accept contin-
ual transformation, look for it, yearn for it, create it. Yet we cower before

I don't know anything about music. In my line you don't have to.

—*Elvis Presley (1935-1977)*

change; we strive to keep sameness. We approach creative assignments in a methodical way: First I must have a clean desk before I try to write even a single sentence. I must not have any music on; it's too distracting. I must warn every person in this household that if they interrupt me they will be immediately beheaded, no questions asked!

My goal for this chapter is to suggest first that change is imperative. We must see outside of ourselves, break habits, do things differently, to be able to see and therefore create differently. To mimic the typical is a cop-out. We need to incessantly search for ways to get ourselves out of the four corners and into spheres of creative continuity that will not bind us. I believe that most of us do not even realize we are bound to doing things certain ways. Gasp! Me? In a routine? If you are smart enough to acknowledge your own routines then you're on a fine start to getting yourself out of your box, even if you are quite comfortable with your box, thank you! Getting out is the only way to move forward, explore, change, create with originality.

I n 1986 Ed Harris's father gave him a book on Jackson Pollock, telling him he looked a lot like the artist himself. Ed became overwhelmed with what would be a ten-year project to direct a film and star as Pollock. He created a studio and taught himself first to paint and then to paint in Pollock's style. On this point Harris is adamant: He learned to paint in Pollock's style, not to copy his work. He admired Pollock for persevering, moving through incredible upheavals in his emotional life to pursue what was in his heart, always his innermost desires. The result is an Academy Award–winning film about Pollock for which Marcia Gay Harden won Best Supporting Actress, directed by Ed Harris who also starred in the title role and received many accolades not normally associated with a biographical film.

I recently attended a "Directors on Directing" seminar at the Santa Barbara Film Festival where Ed Harris, Philip Kaufman (director, *Quills, The Unbearable Lightness of Being*), Michael Bay (director, *Pearl Harbor*), along with several other prominent directors offered advice and comments to aspiring directors and writers within the jam-packed, eager audience. Ed Harris offered the most profound rhetoric of the day, "Don't just evolve, choose the evolution." I was enormously disappointed later during the question and answer session when I encouraged him to elaborate on his quote by asking, "As a director, ultimately responsible for so many creative people, tasks, the film budget and schedule, how do you personally keep yourself out of the proverbial box, being so constantly hemmed in by such conflicting demands?" His answer was, "Well, you just do it, you're a director, that's what you do."

I was expecting an answer like, "Well, I meditate for thirty minutes

in the morning and thirty minutes in the afternoon," or, " I go to my studio and paint every night for forty-five minutes to clear my head," or, "I tell my seven-year-old daddy needs quiet time for one hour as soon as I get home." His ambiguous reply left me empty. When I took the time to ponder on it some more I realized that his answer was crystal clear in its profound simplicity, albeit saddening. Practically all of us do what we do by just doing it, no matter what it is. We're numb, gliding through the motions, getting things done, checking off our task lists.

I know I go crazy with this repetition, and I watch other people lose their sanity doing it too. The expectations we place on ourselves to produce, to make money, to get dinner on the table, to drive a nicer car, whatever, we do just go around getting things done, blindly, for the most part. Well, it's time to stop. Take a deep breath from your innermost chakra and change. So much of this book is about changing, it seems. But the types of changes I am endorsing involve no particular strain of intelligence. It's more about clearing away some clutter for at least long enough to get a picture of our box, then deciding how to get out of it once in a while.

Until just over a year ago, my personal box was projects, projects, and more projects. There were so many things I wanted to accomplish in this lifetime. I spent way too much time planning and thinking about my future instead of living in the present moment. No matter how many projects I completed, I had another and yet another bigger one to accomplish and they never seemed to fulfill me. I think the graphic design business taught me this because it is all about meeting one deadline while simultaneously being immersed in a plethora of others. Seeing a project finally in print became anticlimactic. Seeing one of my

books published, with a real cover gracing my hard work, was not so thrilling. Too bad.

I made a conscious effort to get that old enthusiasm back, to be cognizant of my box and do whatever it takes once in a while to get out of it, walk, swim or crawl. I realized that what may seem like self-control greatly affects our creativity. I learned about living in the present moment from many writings by Thich Naht Hahn in which I became engrossed. *Be Still and Know* is a small but very powerful book that I carried with me for almost a year while searching for some stimuli from outside my container.

To really be in the present moment brings great joy and rewards my creativity. The biggest surprise is that now I realize almost immediately when I am in my box, and outside is always where I would rather be! Inside it's dark, stagnant, my view is not 360 degrees. Anxiety and exhaustion permeate the box. Outside the box I take one day a week and promise myself I will not check my e-mail. I will not sit at my desk, I will not think about money or work, I will not ask myself what I am going to produce that week. I used to relish being the ultimate producer, overbooking appointments, running late, running, always running the marathon. Now, I am by no means less productive but I am much happier. Taking the time to run free from my box has actually resulted in more creativity, better ideas, better personal results.

I once admired hats longingly at nice department stores but knew that I never looked good in them; they were for ladies with long hair and perfect noses. The Theo-lady in the box would never wear a hat. What happened when she finally put one on? A huge transformation of personality, style, spirit, creativity. It was fun to be a person in a hat.

thinking out of the proverbial box

How simple it was to be Theo with a hat on, an altered Theo. It made me look different, act different, see myself distinctively. It was just a hat but it did all these things!

Nancy Meyers, director of *What Women Want,* starring Mel Gibson, tells a great story about directing Mel through a dancing scene in that movie. They almost did not cast him for the lead because in pre-rehearsals he was a terrible dancer. During the shoot several takes were completed and instead of getting better he only got worse. Then someone gave him a hat. Suddenly he started dancing great; he totally escaped into the prop. What happens when you put on a hat? Try it once in a while; you will probably surprise yourself.

Ernest Hemingway, Virginia Woolf and Lewis Carroll all wrote at standing desks. Can you imagine the horror? Try it; I loved it. At the kitchen counter I can look out and see Grass Mountain on a clear day. When I write now I seldom look at the monitor; I look outside. If I look at my computer I get in the box of the monitor and feel congested, boring. If I stand and look at Grass Mountain I am on top of the mountain, on top of my form; it's something different—the entire notion, after all, of doing something typical but in a different way.

Take off your watch for a day. Listen to classical music if you're used to alternative rock. Read the newspaper if you never do. Listen to the news if you're not a newsie. Go hear live jazz if you don't like it. See Blue Man Group if you don't like that kind of thing. Go out and smell the geraniums; there are countless new scented varieties. Free yourself up for one day this month and don't tell anybody; don't decide what you're going to do till that day comes. Go outside and eat your lunch instead of inhaling it like a Shop-Vac at your desk. Drink Constant

CREATIVE UTOPIA

Comment from the Bigelow Tea Company instead of coffee. Wear orange if you usually don't. Be somewhere you've never been that is within thirty minutes of your home or office. Take a different road to work, not because there is a traffic jam but because you want to see what's there. When is the last time you surprised yourself? Be colorful, literally; put on a show for yourself.

I frequently attend seminars and workshops to catch a fresh glimpse at how other professionals pursue their industries. If you live near a big city, check out the trade shows that are staged at any convention center big enough to host them. Bigger shows are not always better. Usually, they are cheap to attend, sometimes free. If you know nothing about orchids, go to an orchid show. Used book fairs, antique shows and any type of home or design show can be outstanding sources for change and inspiration. The underlying theme is this: Learn what you do not know by doing what you never do. It works.

Let's look at this whole concept in a practical application. I tell my students, employees and colleagues that we are all salespeople. If you are a lawyer, you're selling the jury. If you're a burger flipper, you're selling the customer on the fact that the burger was properly flipped and cooked. If you're a night security guard, you're selling the fact that when the curator comes into the museum you've been protecting all night, nothing will have been stolen. It doesn't take long to persuade everyone that we're little more than salespeople, some of us better at it than others. So, there are at least forty hours in the week when we are selling. How would one remove oneself from such a conformist box? The answer is to change your perception of it. Instead of a lawyer, you become a public servant. Instead of a burger flipper, you're a sous-chef

on his way to a five-star restaurant. Instead of a night watchman, you're the artist who painted the pictures.

Creativity can be enhanced by doing any of these typical things outside of your norm. It is really hard to create an outside environment for yourself, but once you do, you'll get my drift; you'll be building your own boat, sewing your own multicolored sails. It becomes habit-forming to do it another way and, by all means, totally annoying to yourself and others; that's what you want! Looking outside of the box will soon lead to jumping outside and away, far, far away, onto a path toward creative utopia.

CHAPTER GUIDES

- Understand that change is imperative.

- Getting out of our comfort zones is the only way to move forward, explore, create with originality.

- Become cognizant of your work load and learn simplification—at least in discovering your own present moment.

- Change your modus operandi every once in a while. Wear a hat if you never do. Go play in the snow if you don't have time. Dance in your own living room with the entire family.

- Attend workshops or seminars on subjects you are interested in but know little about.

- Learn to do typical things outside of your norm.

CREATIVE UTOPIA

SEEING COLOR DIFFERENTLY

7

One of my early, favorite college assignments in a color theory course was to use primary colors of gouache to create a spectrum of 128 colors. We were taught to carefully blend each color with a precise amount of another to create a perfect poster of assembled two-inch squares of color. "How absolutely wonderful," I remember thinking. I loved the precise application. Brushing the paint backward over an already painted surface created a streaked, unrefined look; one had to be very careful. The logical sense and excellent craftsmanship required to successfully complete the project appealed to my sense of order.

Choosing common sense may obscure our most
creative intentions.

—a Theoism

That is exactly what this chapter is not about! Ever notice how gloomy
you feel when the skies have been gray for so long you have to get your
Crayolas out to see what the color "sky blue" looks like? What do you think
about red cars? Yellow houses? Green sweaters? Every one of these colorful
thoughts evokes a reaction inside of you. Good or bad, no answer is right
or wrong; it's very individualistic. This chapter promises to open your aware-
ness to ideologies about color you can use to get a better understanding
about who you are creatively, and how to use that knowledge to embel-
lish your future creative ambitions.

There are many quantum physical studies on our ability to see color and the omnipresent importance of light as it relates to our vision and selective intake of color. To support some of the more ethereal concepts about color in this chapter, it is important to understand some scientific aspects first. Color is merely the light that is emitted from different wavelengths of electromagnetic energy. Many scientific and metaphysical theorists, including Deepak Chopra, assert that when we are born we can see all electromagnetic rays, including cosmic and radio waves. Most of us see only the middle of the spectrum, which in physics is comprised of red, green and blue-violet, as discovered by Isaac Newton.

As children we learned that red, yellow and blue are the three primary colors and all other colors are created from these. This is true chemically, that is, for colors derived from pigments. Color exuding from a crystal is from spectral light, and the colors you see in the Sunday comics are from chemical or pigment light. Even blind people can sense differentiation in color because it is absorbed via color rays permeating the skin.

Why is all this important? Since the beginning of time, color has been perceived aesthetically. Eve's apple is perceived to be red and Joseph's coat an abundant array of colors. Egyptian pharoahs and medieval kings surrounded themselves with jewels, textiles and temples of magnificent color. Pigments were created by early cavemen and Native Americans to allow them to communicate in a varied manner through their paintings and facial masks. Monet and Van Gogh, along with every known painter before and after them, took color multiple steps further.

seeing color differently

It's hard not to find creative inspiration among so many fascinating and colorful light fixtures at a glass blowing factory, Crete, Greece.

Again, it becomes apparent that perception plays a significant role in our creative being, but let's think about that perception of color with regard to our very being. In the introduction to this book I refer to every adjective as being a perceived value. Color in this chapter therefore becomes an adjective! Please bear with me.

Graphic designers and advertisers are well aware of how the perception of color affects the decision making and attitudes of consumers. Blue evokes a calming, generally open feeling and lowers our blood pressure, while red is a call to action, literally stimulating our nervous system. Yellow warms the viewer, connoting happiness, while purple offers a sense of elegance or hierarchy.

CREATIVE UTOPIA

These boats, idly disabled in Jamaica, became the subject of some much more dramatic and colorful creative inspirations, becoming similar to abstract paintings.

seeing color differently

All colors have either a physical or psychological effect on people. Color therapy is an ancient form of healing that, once understood and applied to the different aspects of creativity, can offer outstanding results. Interestingly, the ancient Greek philosopher Hippocrates, creative though he was, dismissed the healing properties of color as being purely metaphysical. We can thank the ancient Egyptians for using color as a healing element and a source of significant well-being.

Color therapy is based on the seven rainbow colors relating to the seven chakras in our bodies. Chakras are energy centers that were first noted in the Vedas, the oldest written words of wisdom initiated in India beginning 600 A.D. Physiologically the chakra system is directly associated with the main aggregations of nerves originating from our spinal column, of which there are seven bundles. The chakra concept was first introduced to the West in a book called *The Serpent Power*, published in 1919, which is a translation by Arthur Avalon of several texts

written by Indian pundits describing the chakras as centers relating the human aspects of physical and psychological. An interesting tenth century text, *Gorakshasthatakam*, gives instructions for meditating on the chakras.

Violet-purple is assigned to the top or crown chakra located at the uppermost area of our head. The brain rests within this chakra and is the source of all awareness and perception. Indigo relates to the brow chakra otherwise considered to be the third eye. This chakra is related to our eyes and our sense of trusting our intuition. Blue relates to the throat chakra, which is closely associated with the functions of the throat, including its relation to self-expression. Green is associated with the heart chakra, love. Yellow relates to the solar plexus chakra and cor-relates to self-esteem. Orange relates to the sacral chakra which is in the bottom of the abdomen, the source of self-respect. Red is assigned to the base chakra at the very foundation of the nervous system, which relates to self-awareness.

When any of our chakra's associated organs are impaired or dis-eased, either physically or mentally, this causes an imbalance in our system and thus a problem with creativity. All the chakras as they are historically defined above have amazing connections to our creativity whether or not we are cognizant of their relevance. Western scientific thinking tends to scoff at these theories. However, many of us are turn-ing to alternative ways of thinking and applying these new thoughts to our daily activities. It certainly cannot hurt us to think in these terms if indeed it will help us.

Now that we understand the mechanics of color it is enlightening to take that knowledge a step further and apply it to different possibilities.

seeing color differently

CREATIVE UTOPIA

seeing color differently

Over time fashion and home design colors pass in and out of vogue in phase with different historical occurences. This relates directly to the use of color as sensory therapy. Blue has repeatedly come into fashion during times when there is a need for peace and serenity. Red is more popular during times of war and conflict representing not only the danger but the courage and new blood such endeavors require.

Wearing certain colors can make us feel a certain way. For many years I would only wear black and white, especially in business situations. I was in total business mode at that time. It made me feel fashionable and powerful. It didn't do a pinhead's worth of generating any creative juices, but it sure was great for negotiating sessions regarding clients' budgets, big presentations where everyone's attention was

CREATIVE UTOPIA

Kirlian photogra-
phy uses biofeed-
back technology
to detect a
person's spiritual
energy. This
photo and analy-
sis were provided
by Progen Aura
Imaging Systems
(www.auraphoto
.com).

required—an outstanding color duo for the boss cow! (Have you ever seen a purple cow?)

Nature has given us countless options for color, and it is up to each of us individually to discern how colors enhance our creative spirit. During those many years of day-to-day business management of my design firm, the black and white I wore kept me from exploring my personal creativity. I didn't have the time and I needed to be all business. I did not realize until years later how I was keeping my creative self stowed safely away by choosing to wear only black and white. I believe that I did not allow myself even on weekends to add color to my persona because I felt a subconscious need to stay very focused on busi-

seeing color differently

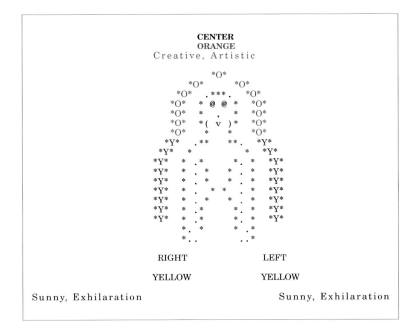

```
                    CENTER
                    ORANGE
              Creative, Artistic
                     *O*
               *O*         *O*
             *O*   .***.   *O*
            *O*   * @ @ *   *O*
            *O*   *   ,   *   *O*
            *O*   *( v )*   *O*
            *O*   *     *   *O*
            *Y*   .**   **.   *Y*
           *Y*   *         *   *Y*
          *Y*  * . *     * . *  *Y*
          *Y*  *  . *    *  . *  *Y*
          *Y*  * . *     * . *  *Y*
          *Y*  * .  * *  * . *  *Y*
          *Y*  * . *     * . *  *Y*
          *Y*  *  . *    *  . *  *Y*
          *Y*  * . *     *  . *  *Y*
               * . *     * . *
               *  . .     . . *
```

RIGHT LEFT

YELLOW YELLOW

Sunny, Exhilaration Sunny, Exhilaration

ness. I became more and more frustrated, yes; and I wish now that I had given myself the permission to cut loose once in a while!

In Pam Oslie's recent book, *Life Colors: What the Colors in Your Aura Reveal*, she shares unique qualitative levels of color theory. Her book includes a self-administered test to determine your own "life colors" out of fourteen possible colors. Pam believes that we are all born with a dominant color aura or color combination that surrounds our bodies. Each life aura is correlated to sets of typical occupations held by people in those color groups. She can actually see the auras and agrees with many theorists that as young children we are taught to see things

like shapes and colors only within certain parameters, thus losing many inherent capabilities—such as seeing people's auras, for one! Her theories are proven with Kirlian photography, which actually reveals and captures auras on film.

Understanding your personal aura life color can greatly awaken your creativity. Some of the aura colors themselves naturally evoke creativity; for example, to own a yellow aura means that you are probably a writer, artist or musician. Violet auras are also very creative, usually outwardly so, suggesting you possess a message to share with the world. Orange auras represent daredevil types like skydivers, race car drivers, firefighters, etc. while a green aura, representing money, typically belongs to a stockbroker, business owner or salesperson. Pam outlines twenty-three color aura combinations in her book as being representative of certain professions and personality types. Understanding the different aura colors can help you realize the types of professions in which you might be most successful. More importantly, it will help you understand your inherent domain with regard to your life work, both personal and professional.

Pam helped me to further understand her color theories by describing that each color aura itself owns a creative possibility. For example "tans" (people with tan auras) are scientific and enjoy acquiring data and performing mathematical calculations that result in a solution or invention. Interestingly, Albert Einstein was a yellow-violet with some green; previously in this book I analogized the perception of creativity with regard to Albert Einstein—my perception that he was incredibly intelligent versus my locksmith's perceiving his intelligence as awesome creativity. So the beautiful thing with regard to under-

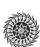

standing your life color is that each color aura is capable of emitting creativity; the type of actual creative output is directly relative to the color aura.

To further our understanding of this concept I asked Pam to elaborate on other color auras. Each of the different aura colors has a propensity toward creative fulfillment. Reds create physical change or expression, whether it is the construction of a house, the repair of a car or the development of a farm. Blues like to create relationships and families. Creating a bridge or mathematical equation means absolutely nothing to a blue. Many people combine aura colors; for example, a tan-yellow combination usually belongs to an architect, engineer or someone who combines a science with an output of physical creativity to produce a building or mechanical object.

I asked Pam whether or not people could add an aura to their personal domain through academic training. She explained to me that I was born a yellow-violet; yellows are creative, fun-loving and free-spirited people; violets want to make a difference on the planet, educate the masses, get a higher consciousness going. I added green to my aura by starting my own business at a very young age out of necessity to survive, to provide for myself and others; it's quite possible that my business skills were learned because of my violet aura, which gives me a stepping-stone to educating the masses (typical of the desires of a violet person). Writing this informative book, for example, was something I felt strongly about doing in my lifetime. My ownership of a graphic design business allowed me to build a relationship with the publisher of this book, for whom I previously wrote graphic design business books. The relationship grew, allowing me to pursue new, more creative endeavors.

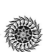

People add colors in their outer aura bands for many reasons and learn to create in the mode applicable to those colors. Pam's aura theory explains that the auras we personally create in our outer bands for those external reasons typically cause dissatisfaction and anxiety for us. We need to revert to our inherent life colors for personal reward. I totally agree. I am happiest when I feel free to create whatever is on my mind at any given moment (my yellow) and when I am writing or expressing myself to others (my violet).

The business side of me is totally there to pay the bills, and when I am "green" I am not the nice, fun-loving person I tend to be when I am living in my original yellow-violet mode. Within the last several years, as I have gotten older and more in tune with my own processes, I have noticed that I do not like myself too much when I'm all business, negotiating, discussing money, working on budgets, financial statements, paying bills. I have taught myself to do it well, but when I get on business overload I become a person I would rather not be around too often! Now I know why, and can use that understanding to give myself permission to be who I need and want to be on given occasions.

If we choose to add colors in our outer aura bands for the specific reasons of adding dimension, adventure and experience, the outcome is usually positive. More people add colors to their outer bands because they think who they really are—their original colors—are not OK, in which case disillusionment and unhappiness are bound to set in. When someone purposely adds a color, they initially risk taking on the negative qualities of that color because they don't know how to use the power of that color proactively.

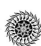

For example, when someone adds yellow to their aura to become more artistic, they might find themselves too carefree or become addicted to something like overeating. These symptoms are both possible downsides of that color. Adding violet can overwhelm someone who does not own it naturally; he or she might become scattered and lost, trying to juggle the many projects typical to a naturally born violet. To learn how to stay centered with a new color one needs to learn the tools for each of the colors. Yellows, for example, require frequent exercise to stay away from the negative addictions and to maintain a sense of humor. Each of the colors has a different way of staying centered. Learning green that one first identify what one wants, then make a list and go after it before anything else, or you could become accusatory, frustrated and defensive, which is the downside of a green aura.

Pam meets with hundreds of people every year who feel repressed; they come to her to make new discoveries. I asked her for an example of someone whose new understanding of their life color enhanced their creativity. One client came to her as a firefighter and was very unhappy, unfulfilled personally. Pam identified her colors as being yellow-violet. Yellows need total freedom, and violets generally need to work for themselves. Working with Pam, the client remembered that when she was growing up she always said she wanted to work with dolphins; her parents had squelched that desire because it seemed too illogical (they were obviously tans or greens!). She is now a marine biologist, making a real difference in dolphin study, swimming with them, photographing and studying them. Thirty years ago, she was way ahead of her time, which is typical of violets. The studies she is pursuing now did not even exist when she was young.

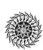

These photos, also from Progen, show the range of colors that can appear in auras.

seeing color differently

Using the tools of our own life colors can help to get us unstuck when we find ourselves in personal quagmires. For example, if I am painting a picture or designing a new product and feel stuck, the best thing for me is to go out and exercise, do yoga, or divert to my sense of humor as a relaxation technique, any one of which activities will open up my creative (yellow) abilities again. Stepping back, getting the bigger picture, turning on the light bulb is easy when I understand the tools to move me in the right direction.

Many of us take positions and make choices in life, personally and professionally, that give us a new aura color in our outer band. The unfortunately frequent result is that we face constant frustrations and peril because we are going against our given life colors. We do this because of the expectations of our family, peers, society, our desire to fit in, our fear, our need to survive—most artists are taught that we cannot survive without a business or profession of some type. This quest for survival and ignoring of our inner voices and life colors force us to undertake new colors and pathways. Your aura colors reveal your inherent theme, what you chose at birth to do in your lifetime. They do not control us, they reflect off us. Whether or not we can physically see them, they are there, reflecting; we can sense them.

There are no right, wrong, good or bad colors. An orange should never feel compelled to become a violet. The colors offer different experiences. Our auras together, as a community, create a prism of totality. Pam's intention in introducing this color theory to the masses (she owns some violet in her aura!) is to give those of us endeavoring to understand our life message some unique data, some help in discovering what might fulfill us. Happiness and satisfaction come from more un-

derstanding, confirming ourselves and giving ourselves permission to feel what we have been feeling inside all our lives. It is our personal responsibility to discover our own natural aura; we owe it to ourselves. Let this learning be a lesson to us in discovering our foundation and finding comfort in that originality. This is one of the keys to finding creative utopia.

CHAPTER GUIDES

- Think about how your perception of color affects your very being.

- Get in touch with how certain colors make you feel. What feelings do certain colors evoke for you?

- Discover your own personal life aura. Does it correlate with who you think you are?

- Understand that each color aura itself owns a creative possibility.

- Being in touch with your inherent life color will provide personal reward and satisfaction. Going against your inherent colors will typically create dissatisfaction and anxiety.

- We all have built-in tools that come with our color auras that exist to help us get unstuck.

- There are no right, wrong, good or bad colors.

PUTTING THE STORM INTO BRAINSTORM

8

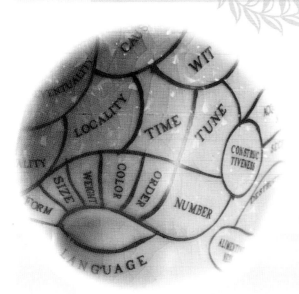

In her book, *Double Your Brain Power,* Jean Marie Stine suggests, "Exercising just twelve minutes per day increases your brain power by 30 percent." Most of us could accomplish that by taking the stairs instead of the elevator, walking the dog around a couple blocks instead of letting her out and waiting there until she comes back, or parking in the back lot instead of cursing while you wait for the valet.

Brainstorming isn't just for those of us working in the creative industries. The actual practice was indeed introduced by an advertising executive, Alex Osborn, in his 1962 book entitled *Applied Imagination.* He identified brainstorming in an effort to develop imaginative and innovative solutions instead of the more typical process of evaluating and then criticizing ideas. Anyone in search of their creative utopia needs to learn the art of first cutting the key and then unlocking the powerful attributes of idea generation. Personal productivity, success, happiness—you name the quality that best describes your perception of living a good life—they all require you to generate ideas so you don't get bored. Apathetic people are everywhere, but they do not exist in a creative utopian environment!

> People seem to concentrate best when demands on them are a bit greater than usual, and they are able to give more than usual. If there is too little demand on them, people are bored. If there is too much for them to handle they get anxious. Flow occurs in that delicate zone between boredom and anxiety.
>
> —*Mihaly Csikszentmihalyi, as quoted in Daniel Goleman,* **Emotional Intelligence**

Good ideas lead to potent characteristics of self-esteem, personal or professional integrity, advancement and self-fulfillment, when they are shared and applied. I had an office manager at Real Art who was probably a more creative thinker than half of the design staff at that time. I always included her in brainstorming sessions. Quite frequently, her ideas would be expanded on and chosen for development. Today she owns an award-winning garden/floral design studio in Texas. Since she left, our office managers for the most part have greatly downplayed their creative aptitudes, hesitating to get involved with the designers; and it's really too bad. Having the perspective of a more "left-brained" staff person is often just what the client ordered!

The next time you are creatively challenged, bring in everyone you can for a brainstorming session. The rules are none. Nothing is stupid or too far-fetched. Anything goes. Make sure someone is taking notes. Better yet, make an audio recording of everything suggested, lest you all forget! Many times something said at the beginning of the session that makes no sense at all might be combined with something said thirty minutes later, for the perfect solution. Don't be shy. Don't cry. Just speak your mind, right now!

Physician Franz Joseph Gall (1758-1828) is credited with birthing the modern ideology of phrenology, which established a direct link between the morphology of the skull and the human capacity to think, to use the brain productively. Research and measurements of the human brain allowed Gall to link precise areas of the brain to specific aspects of character and intelligence. The bigger the head—literally speaking—the bigger the brain, the bigger the capacity to think and create! In Victorian times, the phrenologist was relegated to the realm of astrologists and con men who traveled with circuses, gypsies and magicians.

I became enamored with phrenology as a young girl when I bought a white plaster casting of a head labeled "PHRENOLOGY" at a garage sale. I had no idea what it meant; I just thought it was cool. I have moved this head into many homes, studios and offices since then. It always inspires me; I'm not sure why. I think it's cute. Through the years, after my discovery of the old science, I have conducted an informal survey of people I know. Without exception, those with the bigger heads are the most creative (this is unscientifically substantiated, of course!).

The moral of the story is to derive creative inspiration from those objects from our past, whether tangible or not. They might be songs, memories or movies you've seen. The next time you are searching for new ideas, put away the task at hand and explore for some moments that old item you've been carting around from your childhood bedroom to your frat house to your office and back down to the basement. Picture it in your mind if you cannot hold it in your hands. How might it relate to your task at hand? Could it embellish your presentation? Could it, at the very least, inspire a comment, a laugh, a tear?

putting the storm into brainstorm

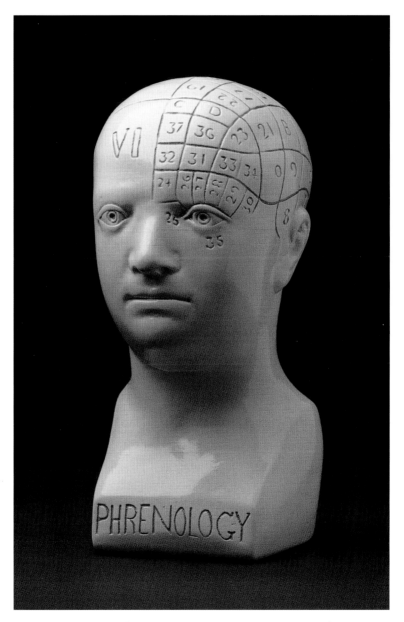

Mr. Cutie: The subject of many a brainstorm session, literally and figuratively!

Anything that elicits an emotion is great for brainstorming, especially with a group. Try this: Ask your colleagues to each bring an item that is meaningful to them to your next brainstorming session. Whether you're scheming up the next big advertising campaign for Nike or thinking of a new design for the space shuttle control panel, just do it (no pun intended). Give everyone a few minutes to show off their item and explain its personal significance to them, why they decided to share it.

Then begin your brainstorming with everyone's stuff in the middle of the group, on display. On the first go-round, have each person associate the item he or she brought in to the task at hand. For example, my white plaster phrenology head might be associated with creating white plaster, 3-D Nike logos to use on store displays instead of the 2-D versions we usually see. I could push that concept further by adding interesting illumination, lava light balls or other unusual materials within the displays. Before you know it, the phrenology head isn't part of the idea at all anymore, but it has opened the door to some new thinking.

The second go-round, have everyone associate an item on the table that belongs to someone else with the task at hand. For example, if someone brought in a picture of her beloved grandmother, I might associate that picture with an idea to do an entire Nike campaign for senior citizens. Seniors need exercise; many of them enjoy it. Why not design an entire line of shoes for that growing market? I don't believe that idea has ever been pursued by Nike. Why not? Maybe some Nike execs are reading this right now! This whole "game" is like playing word association, only the idea derives from a thought associated with a familiar object, becoming words when we speak them.

putting the storm into brainstorm

Remember show-and-tell at grade school? It always provoked interesting questions, conversations and creativity. Just because we're adults doesn't mean that we don't need stimulation from our past and things dear to our hearts to awaken some new thinking. These old things live within us for a reason; our attraction to them is no coincidence (see Jung's theory of synchronicity, pg. 140). We can still learn and grow from them. Let us not deny their importance in our history and to our future.

The entire concept I have outlined for you is one of creating discipline within your brainstorming structure. I know that elsewhere in this book I've used the *d* word, and many artists find it taboo. I find it indispensable for creating originality, progress, creativity. We are too inclined to follow the paradigms of what we have been taught academically about right- and left-brained thinking. Trying something as basic and simple as the exercise above is guaranteed to bring an ingenuity to your brainstorming sessions because it is different.

The typical brainstorming session usually revolves around an empty table, maybe some magazines, pizza, beers, a big, empty, white marker board, and someone standing in front of it with some colored markers. I implore my students and staff to be more creative. How can we come up with new ideas by looking at two-dimensional surfaces that contain ideas that are already developed? Everyone, no matter what the profession, needs reference material to come up with new ideas, but stereotypical reference material will result in stereotyped ideas. Leonardo da Vinci is considered a master; he was the first person to draw medically accurate representations of the human body. His detailed physiological drawings of man came not from typical observa-

tion. He studied cadavers, literally removing muscles from bone to un-derstand their dimensionality and connectivity to the human body as a whole. His (then) new approach to research for art's sake won him outstanding results from studying the human form for artistic applica-tion. He also earned unconditional respect from the medical profession of that and subsequent times.

The rules at the typical brainstorming session are usually that any-thing goes, a free-for-all, try-anything attitude. But I find the person at the marker board writing so voraciously that he doesn't have even a second to shout out something discernible; all too often the shouting gets silly and the entire session becomes totally unproductive. Putting some discipline into the session as described above will help us to get to know one another better, establishing respect and creating a forum for people at the table who do not often speak their mind, intimidated by others who think on their toes more quickly.

Group dynamics play a very curious role in brainstorming. Criticism by others can kill ideas or hamper a more introverted person from shar-ing something truly profound the next time. Seemingly weird or wild ideas can trigger something applicable to the problem at hand from an-other participant. It is important that a brainstorming group be led by someone who is open and flexible, intuitive enough to ask questions of the participants to take them to the next level. This person is not al-ways the strongest, most vociferous person in the group. Everyone on your team should take turns leading brainstorming sessions, which will result in different outcomes. The main objective of the leader is to draw information from the less talkative people in the group. Brainstorming is like shooting a roll of film. A photographer friend once told me, "If you

get one good shot from every roll of film you shoot, you'll be incredibly successful." Same thing with ideas—one good one is all you need.

Go outside. Try to do your brainstorming out of your typical professional environment. Sitting around in someone's cubicle doesn't get it. Try Georgia O'Keeffe's technique of putting on some music and having everyone draw the music being heard. Do this for just twenty minutes, like a meditation. This will focus your energy on creating art forms, abstract or literal. Whether you are an artist or not doesn't matter; the diversion into another way of thinking and listening will relax the participants' minds and take the intent focus away from the problem to be brainstormed. When the twenty minutes of drawing or painting are over, take a few minutes for refreshment and walk around and look at what everyone else has created before you begin the brainstorming session. This concept is much like cleansing your palette with a nice sorbet before a multicourse meal at a delightful French restaurant; it always makes the flavors more robust, more sincere. The ideas will abound with originality!

I have found incredible success in coming up with new ideas by doing what I call "thinking out loud." In social situations or even one-on-one conversations I bring up items of interest that I have heard, say, on NPR or read in current magazines. The reactions of the group or guest whom I am entertaining are almost always insightful, expanding on the subject matter. This process has become almost addictive for me. I can hardly be in a group or have dinner with someone when I don't pull out my handy notebook to jot down concepts that I don't want to forget. Most of the time, the ideas are totally irrelevant to my current projects, but they always seem to come in quite handy when I need an

idea to help me get started on something new. I keep many notebooks of different shapes, sizes and colors everywhere. Some fit better than others into a pocket, a beach bag, my briefcase. When I am stuck or looking for something in particular I flip through my notebooks; I have never been skunked yet!

Brainstorming can be done very effectively by yourself or with a very large group. The practices suggested here will simply get you started. Create a discipline, whether it is to start with a show-and-tell or try to take notes inconspicuously while you're trying to have a good time (sometimes you're better off running to a bathroom stall!). Find new processes that work for you; don't keep going through the same brainstorm routine. If you do, the doldrums are soon to pound a booming empty resonance into your head. Trying new ways of brainstorming is extremely relevant to creativity, to finding your personal creative utopia.

putting the storm into brainstorm

CHAPTER GUIDES

- Good ideas lead to potent characteristics of self-esteem, personal or professional integrity, advancement and self-fulfillment when they are shared and applied.

- Make an audio recording of your brainstorming session where the rules are none and nothing is too far-fetched.

- Derive creative inspiration from items from your past, whether tangible or not.

- Try a brainstorming session by having a good, old fashioned show-and-tell.

- After the show-and-tell, have everyone go around the table and relate his or her object to the task at hand.

- Then have everyone at the table go around and associate someone else's object with the task at hand.

- Everyone on your creative team (even the office manager!) should take turns leading brainstorm sessions.

- Take personal notes on interesting issues that arise at brainstorming sessions.

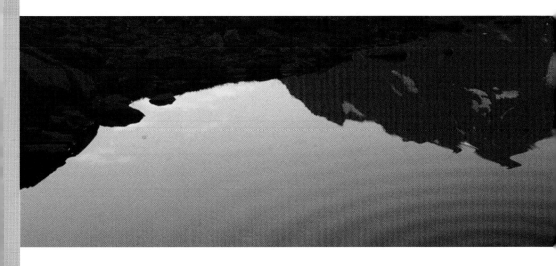

FATEFUL ENCOUNTERS

9

A wonderful friend introduced me to the concept that "there are no coincidences." She is a psychiatric nurse. I have not asked her if she made this determination from the writings of Carl Jung; however, I am convinced now that she probably did. It is much simpler to live our lives ignoring coincidences and labeling them as sheer happenstance. It is safer to live this way. But I believe that true creative utopia cannot be realized without unlocking the possibilities—all of them—and leaving our doors forever open. Should their openness deliver a soothing wind or a heavy zephyr that slams them shut, there is creativity to be realized, lessons to be remembered, always.

Behave as if you have coincidences in your life, expect them, when you are ready to receive them, they'll come.

—*Dr. Bernie Siegel, from Preface, Yitta Halberstam and Judith Leventhal,* Small Miracles

I am convinced that fateful encounters are everywhere and ours to personally acknowledge their presence and individual meaning. It is exciting to think, at the beginning of the day, that creative inspiration is waiting perhaps at the first stoplight, maybe at the third, or fourth, but waiting somewhere nonetheless for our own personal discovery. It is our choice to seek it out, or bury it in our preoccupation with the myriad of other things to which we must be tending. But it's always there, under a rock, in your dirty laundry, on your next nigiri sushi platter!

Perhaps you are wondering just how, exactly, a coincidence or fateful encounter can enhance your creativity. I'll give you a basic example before looking at some case studies: performing research on the Internet. You punch in a keyword and before you know it you've traveled halfway around the world from site to site and, in many cases, keyword long forgotten because you have stumbled upon something else even more interesting. That is creativity! You have given yourself the freedom to explore, to seek out new information, to look beyond the probable.

Everyone knows the story about Benjamin Franklin's stumbling upon the discovery of electricity. He's out flying a kite on a blustery evening, dramatic thunderheads rumbling above. Did he plan for the resulting zap of lightning? Was he hoping to have this electrifying experience? Of course not. Had he chosen to ignore the creative possibilities introduced to him during this fateful moment, chosen instead to cower in fear of ever seeing lightning again, brushing it off as an isolated dangerous episode, how might history have been changed?

The guy who invented Post-it notes for the 3M Corporation did so completely by accident. He was endeavoring to develop a much stronger bonding agent and instead came upon this removable glue that stuck to paper but didn't stick to his fingers. Everyone in his office started using these little pieces of paper they cut and burnished with the substance. Their popularity caught on like wildfire. Now you can't go into an office anywhere in America that doesn't use these ingenious little helpers.

Many inventions were realized by fateful encounters, dreams, visions. Our biggest challenge is to be open to receiving them, to capture the message they convey and then *do* something with it upon its

fateful encounters

Carrying only one camera body into a medieval town on the island of Chios, Greece, I was freaked when my light meter stopped working. But the result turned into a good thing. I pushed the Velvia film two extra stops which resulted in this grainy, dramatic look and more saturated color.

The village of Pyrgi on Chios is a dynamic source of wonder for the graphic designer. Every building is immersed in black and white graphics, literally, from floor to ceiling. Again, no light meter.

CREATIVE UTOPIA

Lost looking for the beach on the winding streets of Pythagora in Samos, I looked up and saw these fresh fish begging to have their picture taken. Seemed like a good idea to me.

unanticipated arrival! So often we just don't have the time or we are frustrated by something and cannot *make* the time for what might seem like yet another disturbance. If nothing else, at the end of your day, take a few minutes to think of the things that happened to you that day that might lead to something creative for you. It's never too late to do something about it. Keep an ongoing list in your journal so you don't forget. If someone handed you a hundred dollar bill with no strings attached, you would take it, right? Many fateful encounters offer much more than monetary benefit.

I was in a grim slump at Real Art in 1990. I had owned the business for seven years and was the only salesperson. I was exhausted from working sixty- to eighty-hour weeks, making deadlines, wearing all the

fateful encounters

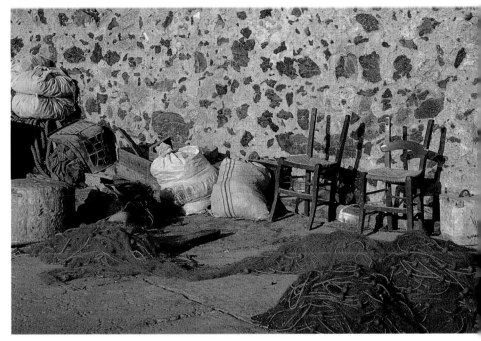

I hiked down a monstrous, precarious, red-rocked mountainside in Santorini to meet a group of artists at this obscure fishing village. While there, I decided to take advantage of the incredible light.

hats. Personally I was going through a painful divorce after witnessing my best friend going through the same thing the year before. I felt disconnected, without much of a support network.

A distant relative passed away. I decided to send a fruit basket to her immediate family. In the car, after ordering it I admonished myself for ordering something so ugly. I knew it would be appreciated, but a *fruit* basket? What in the world had I come to? Why couldn't fruit baskets be arranged in beautiful packaging? Like what? My mind floated to my mom's old hat boxes. I loved looking at them as a young girl. The colors, designs and typographics always promised something special awaiting inside.

Cub Foods packaging for fruit gifts.

I went back to Real Art and asked one of my illustrators to do some artwork for some hexagon-shaped "hat boxes" using the Cub Foods logo, showing their usage as gift boxes for fruit. I knew Cub sold a ton of fruit baskets during the holidays—every grocery store does! I had an old friend whom I really missed and who was now working for Cub Foods in Minnesota. My idea was to go on a "business" trip, reconnect and get uplifted by my girlfriend while possibly getting someone at Cub interested in some new packaging concepts for their fruit gifts.

My friend warned me not to get my hopes up too high but said she would love to see me. When I met with her superior to show the concept boards, neither one of us knew that Cub was getting ready to enter

into their first ever print marketing campaign. They were looking for a unique illustration style in which to produce their national campaign! They loved the artwork. Did I have enough staff to produce several hundred pieces of art, and beyond that, was I interested in designing the entire campaign?

Was I? Real Art produced Cub's first print campaign and kept it going for over five years. The hat boxes? They only produced twenty-five hundred of them. The produce manager loved them, but they were more expensive than the typical, cheap wicker and too much "work" for the produce departments to assemble. The end result of the print work? Over two million dollars in revenue for the firm. The fateful encounter, my attempt to sell one idea, rolled seamlessly into a much larger opportunity. Why? Because I was open to the coincidence and the subsequent outcome even though it was not what I had expected or planned.

There is nothing magical about being at the right place at the right time. And I never believe in luck; as a matter of fact, I feel hurt when my friends or family tell me how "lucky" I am. "I work hard," I tell deaf ears; "I deserve to reap the fruits of my labor," I bellow, trying to convice myself. The truth of the matter is a very simple one. My door is always open to pursuing any new ideas that come my way, no matter how far-fetched they might seem. If I can justify an action for a possible result, I'll usually go for it. I don't win all the time, but the times I do win make it worth trying all over again.

Take the ultrasad story of Van Gogh. He was tortured by his lack of perceived capability, productivity, ability to be recognized by others. He had incredible fateful encounters with sunflowers, scenes that he took to another dimension beyond ordinary life with his color selection

An incredibly fateful moment in the Serengeti. My first fate, coming across a pond, rarely remaining this long after winter rains. My second, the perfect symmetry of the tree on the horizon embraced by the towering cumulus behind it.

and unique execution of style. His work is now some of the most sought after in the history of art! His brother Theo encouraged him and believed in him, yet he did not believe in himself. Juxtapose his story with that of Monet, who reveled in his experiences, built a fabulous home and gardens using his creative genius and lived to know his popularity within his own time period. Monet boasted with open doors; Van Gogh cried because of them.

fateful encounters

This delightful Massai woman saw my camera and pointed for me to take her picture. I knew it was dark and I wasn't carrying a flash, but my reward was to capture (not even knowing how) the glimmer in her eyes.

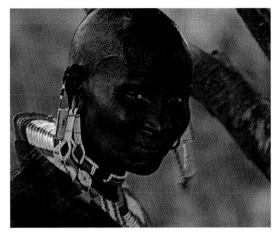

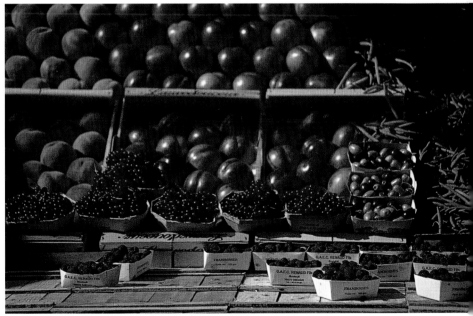

The quaint neighborhood markets in Paris always promise the best compositions. I was totally at the right place, at the right time to see this beautiful light on the morning's fresh bounty. By the way, when you buy any produce in France, you let the proprietor choose it for you . . . that's how they keep it unbruised and picture-perfect. This orderly process is an offense to some foreigners, a dream to an artist seeking perfection.

CREATIVE UTOPIA

Far beyond the countless case studies, there are the observations of Carl Jung, world renowned psychologist, whose theories have superseded those of Sigmund Freud in most applications of modern psychological rationale. Jung published and taught volumes on his "theory of meaningful coincidence." To Jung, synchronicity was synonymous with human destiny. Countless Jungian followers—most notably Ira Progoff—have continued to research this profound concept, the origin of its manifestations and the conviction of the inevitability of synchronicity in our lives.

The theory takes meaningful coincidences or fateful encounters and correlates them to human experiences of all kinds, noting what their intertwining details imply for understanding mankind in total. Jung, in his introduction to a newly translated version of the *I Ching* in 1950, states, ". . . I have termed synchronicity, a concept that formulates a point of view diametrically opposed to that of causality. Since the latter is a merely statistical truth and not absolute, it is a sort of working hypothesis of how events evolve one out of another, whereas synchronicity takes the coincidence of events in space and time as meaning something more than mere chance, namely, a peculiar interdependence of objective events among themselves as well as with the subjective (psychic) states of the observer or observers."[1]

I belonged to a Jungian theory dream group for several years in the early 1990s. Carl Jung's theories of dream analysis include the concept that, if you dream of someone, it is not really the person themself you

1. Progoff, Ira, 1987, *Jung, Synchronicity, and Human Destiny: C.G. Jung's Theory of Meaningful Coincidence*, Julian Press, New York. Original quote from the *I Ching*, translated by Richard Wilhelm and Cary F. Baynes, foreword by C.G. Jung. Bollingen Series XIX, Princeton, N.J.: Princeton University Press, 1950, 1969.

fateful encounters

I met Matthew Brzostoski on a trip I took to Jamaica while riding my rent-
ed bicycle past some colorful paintings galleried along lazy West End Road
in Jamaica—in 1990, hardly a hot tourist location. Matthew and I struck up
an interesting conversation and I bought two beautiful paintings from him
for $20 each . . . he had just started painting. Now Matthew shows his work
at galleries and art fairs around the world—at prices far exceeding $20! I
have kept up with his work on the Internet. A wonderful example of yet an-
other fateful encounter. © *Matthew Brzostoski 1990*

CREATIVE UTOPIA

I'm not much of a morning person. But I was awakened pre-dawn by a quick-burst thunderstorm up on Lake Huron, which evolved quickly into a beautiful day. Riding my bike down the drive I noticed the incredible light and moisture on these spider webs and decided to try to capture it.

are dreaming of. Rather, it is the part of you that relates to that person that you are dreaming of. Same thing with objects. If you dream of a green window, for example, it is not the actual green window about which you are dreaming. It is the part of you that you relate to the color green and windows, as a metaphor perhaps. The group I belonged to would take turns asking each other questions that helped us each determine the unique synchronistic values of our dreams. The result was fascinating answers to our inner psyche and creative spirit.

Many people don't remember their dreams. My husband was convinced that his dreams were always foolish, over the edge; he hardly

dreams at all. The truth is that we all dream; some of us just remember them more easily than others do. I have asked Joel to share a dream or two, no matter how stupid sounding. Via a series of questions—e.g., "What part of you do you relate to your cousin Sam?" or, "What do you have in common with a gray elephant munching peanuts at the zoo?" Joel has realized the messages these dreams are conveying to him. Answering these questions has turned a pessimist into a believer. The realizations are there if he takes the time to sort through their symbolic meaning, even though his remembrances are very narrowed. It doesn't matter. A message is a message after all.

A wonderful creative gift to yourself is one where you take just a few minutes every morning before you get out of bed and record your dreams, either on a voice-activated recorder, or by writing. You'll forget about them by the time you are fully awake. When you get a chance, review the dream and assign the parts of yourself that are related to the people or things you dreamed about. This is a wonderful, natural way that our brain communicates creatively with us; it's there for the listening!

Chance meetings are available to us every day. We go to meetings, to the grocery store, get on airplanes. Many of us are rather introverted and keep to ourselves. We do not seek eye contact from others, let alone smile or strike up a conversation. But when we do, the rewards can be quite beneficial. Sometimes the creative result is for the other person, and it can feel very good to us as the "giver" to have made someone aware of something.

When Joel and I decided we wanted to move to California, I flew to Los Angeles to show Real Art's portfolio to some friends and colleagues to assess the feasibility of forming a West Coast office for the firm. One

of my business partners came along with me and we decided to go to dinner at The Ivy, where some popular scenes from the movie *Get Shorty* had recently been shot. We wanted to be at the center of a very hip place on our last night in L.A. We were in a celebratory mood; the meetings had gone well.

The tables on the happening patio being only inches apart, we struck up a conversation with a man seated next to us waiting alone for his dinner guest. When his brother arrived we continued our camaraderie by buying a round of drinks; it was the first guy's birthday, and we were all a little happy-faced from waiting so long for dinner. The brother turned out to be the president of Universal Studios at that time. He offered to meet with us the next time we were in town to review our work and then introduce us to some Universal staff who were buyers of graphic design.

John and I called him a few days after we returned and told him we were coming back to L.A. (we had no reason to return except to take him up on his offer). We made an appointment with him, showed him our work, and within six months I had generated enough volume with Universal to afford my relocation. Presto. It did take hard work and perseverance, but I believe that this had absolutely nothing to do with luck and all to do with synchronicity and the powerful creative results that can be derived from coincidence.

Mentors are extremely important to our creative process, awareness and growth. They too come into our lives fatefully, when we least expect them. Use your intuition (see chapter eleven) to guide you in being open to meeting others in situations not typical for you. Challenge yourself. The worst thing that can happen is that you smile at a few people

and you meet no one; nothing happens. The alternative could change your life for the better, forever.

Fateful encounters with people, places and things are everywhere, all the time. Take a look, maybe just a *fresh* look at everything around you, every day. The billboard that has been sitting at the base of your most-used highway ramp may hold a message you had never before acknowledged, let alone read. Creative messages and inspiration abound everywhere. Come out of your shell and seek anew.

CHAPTER GUIDES

- There are no coincidences; everything happens for a reason.

- Fateful encounters are everywhere and ours to personally acknowledge their presence and individual meaning.

- Many significant, world-changing inventions were realized by fateful encounters, dreams, visions.

- Carl Jung, world renowned psychologist, has published and taught volumes on his "theory of meaningful coincidence," synchronicity being synonymous with human destiny.

- Record your dreams and try to look at each person or thing in your dream as a part of you that relates to that person or thing. Then you can determine the underlying message of your dream as theorized by Carl Jung.

- Pay very close attention to "chance" meetings and make every attempt to follow through on them. The person we meet during these moments might become our best friend, biggest client or spouse!

MEDITATION 10

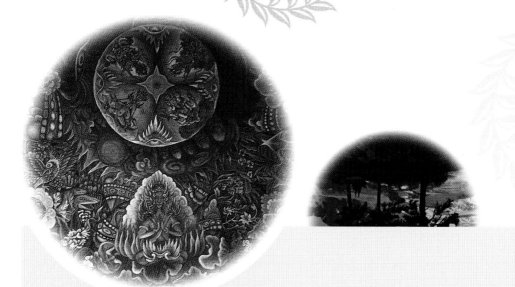

Meditation, like aromather-

apy, has often been considered an occult practice. Some people still look at me sideways when I mention either subject. It has gained popularity as more people become interested in realizing their full creative and life potential, primarily, I believe, from the success of shows like *Oprah* and recent best-selling books from Deepak Chopra, John Gray and His Holiness the Dalai Lama, to name a few. The surge of interest in alternative medicine has also provoked more interest in the subject.

Information on meditation techniques is widely available; even our local community college offers courses on different methodologies. I'm sure yours does too. The purpose of practicing meditation, in my opinion, is to truly realize your limitless personal creative potential. I have implored you throughout the pages of this book to eliminate all aspects of boundaries and anything that even remotely refers to them from your daily vocabulary. Meditation

> You have the power to create the life you want. You are
> not limited by your past.
>
> —*John Gray*, How to Get What You Want and Want What You Have

will take you to a place where you can understand the total scope of free-
dom available to you by ultimately releasing those confines for good.

It's one thing to physically go through the motions of performing a task,
like getting rid of words and trying to be cognizant of your relationship
with their meaning. It's another thing to develop a practice that will take
that "task" and turn it into a natural way of thinking. Meditation will do
that for you.

Meditation is not a difficult thing, nor is it a process that proclaims a
certain religion or philosophical entity. Don't make it more than what it
quite simply is. It does require, however, a commitment to frequency. I liken
the practice to adding small links to a chain every day. You can't do much
with a chain that is a few links long. But a chain with thirty links might hang
a pretty basket, a chain with one hundred links might drop an anchor, a
chain with six hundred links might rescue someone in peril, and so on.
Meditation is a cumulative tool; the more you practice, the more results
you will see, subtly but significantly, over time.

I t is very important before you choose your meditation style to understand your own personal process preferences (see chapter twelve for techniques on learning more academically about this subject). Take a look at yourself—and not in the mirror—at exactly "how" you typically "are" from a personal lifestyle preference and also from a productivity perspective, be it personal or professional.

When you listen to a lecture are you jittery, do you find it hard to sit in one place even during an engaging movie? Does your foot swing up and down or from side to side quickly when you cross your legs? When you create a painting or drawing do your tools run with zeal over the flat surfaces, are you unable to express yourself fast enough? Or would you rather do several sketch options first, then slowly contemplate each color, every stroke? The same analogies can be applied to preparing a report for work or approaching a mechanical problem or assembly. How many of us (me!) never read instructions but commence the assembly of those Christmas Eve toys like a mad scientist?

No process is better, more creative, than another. It is very important not to judge yourself (or others) for your process preferences. Having an understanding of your "way" will give you some keen insight as to what meditation styles might work best for you. As you develop a consistency with a certain meditation style, I encourage you to maintain also the process of looking at yourself. You will change. It will be good for you to notice the transitions you are making in your thoughts and actions. The very act of noticing the shifts—no matter how minimal—will awaken you with a newness. And any personal newness—any at all—is equal to discovering your unique, individual creativity in some way, shape or form.

meditation

There are many more active styles of meditation that I do not cover in this book that might better fulfill some of your needs. Tai chi is a very beautiful, expressive meditation that is becoming quite popular through weekend workshops and weekly sessions at local community centers. Qui Gong and Falun Gong are two more interactive meditation techniques. Tranquil movements of the head and arms, holding stances and standing quietly unite many active followers to these methods. It is believed that developing agility will increase circulation to the brain and thus creativity!

It was very interesting for me to initially choose a meditation style that was exactly the opposite from my personal process style. My commitment to Transcendental Meditation (TM) was very routine, unlike any other facet of my usually flexible (if not impulsive and compulsive) schedule. I did TM regularly, exactly as I was taught, for over five years. During that time period I kept furthering my reading on what I thought were totally different subject matters, only to find myself learning still about different meditation styles. (See chapter nine for more on fateful encounters.)

Today, I meditate absolutely every day, without faltering. It has naturally become a part of my day, like taking a shower and my vitamins every morning.

Many times, I don't even realize that I am actually meditating. Where I used to need to purposely block out twenty minutes twice a day for the process, I now know that I am going to do it when I am most in need of it. It has taken me over seven years of practice to know that it is now an uncontrived part of my day.

I remember sharing my "twenty minutes, twice a day" regime with other graphic designers, my sister, a girlfriend in Minnesota. They all scoffed at me for one reason or another.

"I don't have that kind of time in my day," retorted my sister, implying that *I* had *all* kinds of time in *my* day. I was just an artist, after all, an artist, I might add, with ten employees at that time, clients on both coasts and a new husband to impress with my "do it all, be it all" capabilities.

My designer colleagues mostly looked at me puzzled, and my employees continually chide me even now for "wanting an answer for world peace." My Minnesota "Cub Foods" girlfriend started calling me "swami."

I was eager to tell people about meditating because it helped me so much; I was convinced that by sharing my experience, it would encourage others to take up the practice. I thought it might be cool to take a twenty-minute meditation break at Real Art and have everyone sit still for twenty minutes on the floor and clear our minds. But alas, Theo is just a weirdo after all. I tell you these stories because today there are over five million transcendental meditators worldwide, according to www.TM.org (the official web site of the Maharishi Yogesh, the originator of TM), compared to 3.6 million people who have owned Ford Explorers in the past eleven years.[1] Most of us just don't talk about it!

My purpose here is to encourage you to perform this life-changing ritual for yourself, and not to be discouraged by the comments or opinions of others.

Perhaps I troubled your meditation intentions earlier by suggesting that you commit to somewhat of a schedule. I can promise you that meditation will add time to your day, not take it away. There is no hard rule about how many minutes you meditate. You will need to find that balance for yourself. Transcendental Meditation experts teach students to perform the exercise twice a day for a minimum of twenty minutes,

[1] According to www.auto.com/industry/ford26_/20000826.html.

meditation

but that is the only form of meditation that carries any specific suggested time frame that I am aware of.

You can have a successful meditation just about anywhere, contrary to popular representations of meditators sitting in a particular position with hands and shoulders situated just so. Make sure you will not be distracted by telephones, people walking in and out or pets. I'm not sure what the dynamic might be, but every time I leave my door open when I'm meditating in the house, my cat Mickey becomes particularly attracted to me. Then the dog appears out of nowhere. It's a wonder the fish don't vault from their tank to join us!

Choose an auspicious time that fits well into your work and lifestyle process. A perfect time is either first thing in the morning or at the pinnacle of your daily hullabaloo. Ideally, meditate at both of these times. Meditating in the morning will help your subconscious to layer your day, allowing your conscious self to make better decisions, set priorities, thus helping you maximize your efficiency. Taking a few minutes to meditate at the height of your day (around 2:00 p.m. for me) will force you to stop and clear you head, making the second half of your day more productive and happier too. Creativity comes when our mind is free to think creatively!

The simplest form of meditation is to close your eyes and be very aware of your breathing. Take a deep breath in; you might even say to yourself, "I am breathing in now," and alternatively, "I am breathing out now." Be extremely aware of every aspect of your breathing in and out—now. It is very important to be in the present, the "now" with your breathing awareness. Your mind will race, your inner voices will chatter. That's OK; that's what they're supposed to be doing. As soon as you realize you are no longer cognizant of your breathing, return to the act of breathing aware-

ness. The things going through your mind and the inner voices chattering away at you will enchantingly become a series of organized directives when you are finished meditating. Keep this awareness breathing going for ten to fifteen minutes at a time if you think you can spare it.

If you have a soft, nonstartling type of alarm—a CD that turns on or a radio with soothing music is perfect—set it for the amount of time you have; that way you won't be preoccupied with looking at your watch to see how much time you have left! When the alarm goes off, don't open your eyes right away. Let your mind come back into the present moment and tell yourself a few times how creative you are. Verbally reward yourself, your creativity. Slowly open your eyes and take a few deep breaths before you go at the untamed beastliness of your day again. Soon you will be the trainer, in control, collected, renewed.

Remember, the time comes back to you tenfold if you give meditation a chance to reward you. It takes about a week for you to get hooked on the process. Funny thing is, after you commit to it and it becomes a part of your day, when you *do* skip it, for whatever reason, your day seems fragmented and incomplete. Even doing it for a few minutes is better than skipping it entirely.

The art of Transcendental Meditation (TM) should perhaps be credited with bringing meditation to a more prominent role in today's society. In 1963, His Holiness Maharishi Mahesh Yogi published *Science of Being and Art of Living,* which has since been read by millions of readers in a multitude of languages. The Maharishi, as he is called by his followers, founded TM, which is the world's most widely practiced meditation technique. Scientific research has found that TM eliminates stress and fatigue, improves health, increases energy and well-being

meditation

and expands mental potential.[2] Deepak Chopra's *Quantum Healing: Exploring the Frontiers of Mind/Body Medicine,* another best-seller from 1989, offers profound statistics supporting the value of TM in our everyday lives for just these reasons.

The Worldwide Transcendental Meditation Movement has established meditation centers in all the major cities of the world, teaching TM in a short-term series of lessons, usually in small groups. I fell in love with TM and practiced it solidly for over five years. I still go back to it frequently and combine it with other techniques. As a student of TM you are given a mantra that your teacher feels is suitable to you personally. The meditation process is then very similar to the breathing awareness exercise, only the mantra is used as an awareness center in place of the breathing. Teachers of TM suggest a disciplined meditation of twenty minutes, twice a day at minimum. Teachers of TM proclaim that if you fall asleep during your practice, that is quite OK; it will be the deepest sleep you have ever experienced. And they are right! When your practice is over you "awaken" totally refreshed.

Zen meditation is a Buddhist method, the very traditional form that we associate with the specific bodily posture of sitting in a pyramidal lotus position. This sitting position is very old; it actually predates Buddhism in India and has been discovered through archaeological research in ancient Egypt.[3] The lotus posture is very important to this meditation style. You can sit on a small pillow (officially called a *zafu*) and shift your body forward a little bit so that your knees touch the ground. This position gives your body a tripod-style, 360 degree stability.

[2] According to www.TM.org.
[3] Johnston, William, 1997, Christian Zen, Fordham Universtiy Press, NY.

In the Zen process you close your mouth, placing your tongue on your upper palate, lower your eyelids and fix your gaze a few feet in front of you. With your tongue and eyes where they are, you won't need to swallow or blink. Your back should also be straight but your muscles soft. It is difficult to train oneself to sit this way, so this style of meditation might require a little more work than the others. There are other acceptable sitting styles, including sitting on a chair, but the original Zen meditation requires this discipline.

The awareness of body, breath and mind as a cohesive unit is significant in Zen meditation. The Zen culture teaches you that two inches below your navel lies the physical and spiritual center of your body, so you need to focus your attention first at that median. Then you find your own center of gravity by gently rocking back and forth until you settle somewhat.

Take very deep breaths from that center portion of your body of which you are now aware. Zen meditation continues similar to the breathing awareness meditation but combines all the disciplines. It is extremely important to concentrate on the breath. Zen masters call this concentration the Joriki, which is the nucleus of Zen martial and visual arts.

My favorite Buddhist teacher, Thich Nhat Hanh, offers many creative styles of meditation in his writings (over seventy books) and instructional tapes. My personal favorite instruction tape of his, *The Art of Mindful Living: How to Bring Love, Compassion, and Inner Peace into Your Daily Life*, introduced me to a series of meditative remarks that particularly strike a creative chord within me. I say them often to myself to get back into the present moment in which being is an incessant, necessary practice of the Buddhist way of life.

meditation

Thay (meaning teacher) teaches "flower/fresh, mountain/solid, water reflecting/calm" for the purpose of our cognizant breathing, as in, "I breath in, I am a flower; I breath out, I am flower fresh. I breathe in, I am a mountain; I breathe out, I am mountain solid. I breathe in, I am water reflecting. I breathe out, I am calm." When I feel creatively burnt out, weak and stressed (usually all three appear simultaneously), this is a quick and wonderful way to snap out of it and into another zone entirely, mine for the simple act.

CHAPTER GUIDES

- Meditation does not proclaim a certain religion or philosophical entity.

- Do not make meditation more difficult than the simple, elementary act that it is.

- Understand your own personal process preferences before choosing a meditation style.

- Explore as many different meditation styles as you can before committing yourself to a pattern that will suit your individuality.

- The benefits of meditation are cumulative. Don't expect big "ahas" as soon as you start to add this regimen to your lifestyle.

- Meditate only for yourself; do not be discouraged by the comments or opinions of others.

- You can have a successful meditation just about anywhere.

- The simplest form of meditation is to be conscious of your breathing, both the in and the out breath. Do this for about twenty minutes.

INTUITIVE THINKING AS A
CREATIVE PATHWAY

11

Intuition is our *given* knowledge.
It cannot be described, judged, altered or manipulated without becoming
undone from its natural state and, therefore, no longer being intuitive.
Many students and employees over the years have asked me about intu-
ition, how to tap into it, how they might know when it starts, what to listen
for. My answer is frustrating to them because I tell them they are the only
ones who can answer that for themselves. It's a gut feeling, an instinct.

My life is a story of the self-realization of the unconscious. Everything in the unconscious seeks outward manifestation, and the personality too desires to evolve . . . and to experience itself as a whole.

—*Carl Jung,* **Memories, Dreams, Reflections**

Creative pathways certainly become clear when we allow our intuition to light the way. Intuition should not be described as a way to manage ourselves because it is unmanageable in itself. It is not an attitude because it cannot be controlled, turned off or turned on. We should never make the excuse that because we are tired we don't know any better, we haven't the answer. The answer is always there, intuitively.

Most of the chapters in this book deal oblique-ly yet ultimately with intuition. We set goals "just knowing" what we want the outcome to be. Choosing subjects for our journal is often done with our "sixth sense," especially in stream-of-thought writing. Mandalas are created from our inner art (read: heart—inner knowledge, intuition). Meditation opens up intu-itive capability. Fateful encounters would not be recognized as such without something innate to guide us to their messages. (See chapter twelve, specifically Myers-Briggs testing on pg. 172 for more on intuition.)

I felt it important to include intuition as a chapter in this book be-cause I take it too much for granted, and too often I am questioned about it. I think a lot of people associate intuition with risk taking. "How did you know the client was going to like the orange cover on his annual report, especially when in the take-in meeting he requested a blue cover instead?" a student intern once quizzed. My answer was to say that I never honestly *knew* how the client would react.

But what I *did* know was that blue seemed too tranquil for a soft-ware development firm. Orange spoke with excitement and was a cur-rent trendy color just as his firm was very successful in creating trends. It just made sense to me to choose the orange and explain why I used it to the client; he responded immediately and favorably. My intern had agreed in the studio that the orange looked better; it was his own se-lection after trying a multitude of blues. But his hesitation prevailed be-cause he was told to use the blue. He doubted his own inner knowledge, his intuition to use the orange. So we printed two covers, one orange, one blue. We showed the client the orange one first. After the orange

was agreed upon unanimously, we presented the blue cover. It was history in seconds. Had we shown only the blue one, it would have unquestionably been approved, for lack of an alternative. The lesson learned is to follow your inner knowledge even if it involves some type of confrontation or risk.

People seem to avoid confrontations at all costs. A confrontation connotes disharmony, a fight, an unenjoyable experience. Not so quickly my friend! Confrontations often challenge someone's intuition. In the above example we did take a risk of the client being adamant about the blue cover. So what? We had nothing to lose; we would've gone back to the blue one, although it was not the "right" choice, had our client absolutely insisted. As professionals we are paid to do what we know and deem as best. All of us, whether we are graphic designers, engineers, lawyers or Indian chiefs, need to be true to ourselves, to our inner knowledge, if we are to be respected. If we sell our soul to the highest bidder, what good will we be to our subordinates? To our personal moral codes? To our own creative spirits?

I achieve what I refer to as "intuition management" with the outside world by thinking of analogies that my clients can easily relate to from their own industry perspectives. And I love nothing more than when someone calls me out on my own tactics. For example, years ago I decided I would save money and create the space planning for a loft condominium in a building I was purchasing. Excitedly, I showed my concepts to an architect friend.

"Theo," she confronted me bullishly, "do you think that I should design my own logo?" She was getting ready to move her offices and would need some updated corporate identity material.

"Hell, no," I replied laughingly, "you're no graphic designer."

"Exactly," she responded, "and you're no architect."

This is an example of how a conflict actually benefited both parties. And usually, done appropriately, conflicts should be healthy for all involved.

I have learned my lesson time and again while trying to second-guess what my clients will want to see in a piece we are creating. I've been sucked into proverbial quicksand by employees thinking the same way. What *should* we show them? What do they *expect* to see? Well now, if I'm the client, and someone shows me what I expect to see, I personally feel gypped; I could've done it myself. On the other hand, if someone shows me something new and explains why it is right for me, I will at once feel a perceived value.

Using our intuition means not worrying about incoming perceptions or expectations. If we trust that we are right, we can at the very least offer an explanation of our choices. Whether we are on the giving or receiving end, being intuitive boils down to being just plain honest, first with ourselves, then with others. We don't want the self-inflicted kick in the pants later, when our inner voice says, "Why didn't I offer him less for that Mustang; I wonder if I could've gotten it cheaper?"

The same analogy applies to creativity, no matter what our profession: Why didn't I try using photos instead of illustration when, as soon as I started the project, I could visualize the actual shots we would include? Why didn't I call off that satellite launch when I thought I had seen the safety sensor blink one too many times? Why did I use that hair coloring she asked for when I knew it would make her look ridiculous? It is our moral obligation to be truthful to our intuition!

Successful application of intuition in our daily lives goes beyond the

intuitive thinking as a creative pathway

internal reaction, the sixth sense. It means being proactive, doing what we love every day. If we hate our jobs, dislike our colleagues, find fault with the transportation system, the political system, the mechanical system, it is ours to change. If we know something is wrong, then we have the answer to fixing it.

This is a big reach for most people. I have a dear friend who hates his factory job. Every day he goes to work and crosses off yet another day on the calendar that brings him closer to retirement. He's been doing this since I met him when he was twenty-seven years old! He is forty-five now; he'll be retiring when he is forty-seven. He is "waiting" to turn on his creative juices, an incredibly artistic individual.

He has chosen to play it safe and ignore his creative tendencies until he retires with his safe income and his even safer investments. Smart man? Maybe.

But maybe not. My own dad was very much the fine artist. He had a terrific singing voice and loved to draw and carve wood objects. "When I retire," he would say wistfully, "I'm going to make you a music box." He had a million and one creative aspirations reserved for retirement day. He was forced into a medical retirement long before he got to re-alize his creative yearnings. His Parkinson's disease kept him from ful-filling dreams he had waited for so patiently. His hands trembling, he warned me during the last years of his life not to wait, "Do the things that are in your heart *now*. You may not have the health to do them later. Don't wait." He was adamant, the urgency in his voice something I will never forget.

Getting to our core, our intuition, sometimes requires finding a quiet place, unplugging, meditating. If you are having a difficult time heeding—

or just plain getting in touch with—your intuition, take an intuition vacation. Even if it is just to take a couple hours off work early, do it, and do it right away. Losing your intuitive capabilities or, worse yet, not knowing or understanding them at all is a red alert, emergency situation that needs your immediate receptivity. Look at it this way. You can keep on ignoring the fact that your intuition exists and live in a tunnel, with mediocre success. Or you can find it, continue to acknowledge it and be rewarded by yourself and others for the integrity of your creative applications.

Don't confuse intuition with impulse. Sometimes we feel forced to make a decision, and out of fear or desire we make what ultimately appears to be the wrong choice. Learn how to ask for what you need. If you need more time, ask for it; more space, arrange for it; more freedom, go for it. No one can read your mind. Intuition is all about reading your own inner thoughts and awareness patterns. In this momentous time with massive amounts of information assaulting us from all angles, it is easy to get the facts mixed up with the inner depths of our own personal knowledge.

In *Some Memories of Drawings*, Georgia O'Keeffe describes a time when she was walking down a hall at Columbia University and heard some unique-sounding music. Curious, she walked into the room and along with the students followed the instructor's request to "draw the music." What an incredibly creative application to put us in touch with our intuition! In the same book, O'Keeffe shares a drawing of a headache she had experienced. When I look at the picture, it looks more like acid indigestion to me! But her intuition led her to the end result of a sought-after drawing. It really doesn't matter what I think, does it?

It's very important to find respite from the chaos. Learn to center on

intuitive thinking as a creative pathway

what you know is the right way and feel the synergy of your connection. It's a lot like dancing. Whether you are a really great dancer or not doesn't matter. Turn on your favorite music. Lock the doors, close the blinds. Now dance. Put on headphones if you need to concentrate or feel distracted. No one is watching. Isn't this fun? Let your body go; let your ears hear every aspect of the music, the deep tenacity of the bass, the resonance of the treble. Free your body to move in whatever way it wants to go. Congratulations. *This* is intuition!

CHAPTER GUIDES

- Intuition is our given, inherent knowledge.

- Creative pathways become clear when we allow our intuition to light the way.

- Confrontations can be healthy, often challenging your intuition.

- Intuition management is a positive way to negotiate by thinking of analogies that your clients can easily relate to from their own industry perspectives.

- Using your intuition means not worrying about incoming perceptions or expectations.

- Successful application of intuition in our daily lives goes beyond the act of using your sixth sense. It means being proactive, doing what we love to do every day.

- Take an intuition vacation if you are having a difficult time heeding or even getting in touch with your intuition.

- Don't confuse intuition with impulse.

PLAYING THE "INSTRUMENTS" **12**

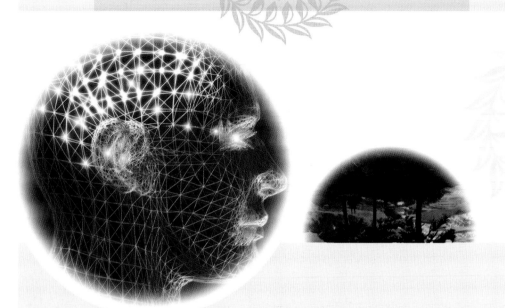

Reflecting on my moments of strongest creativity always takes me back to my terrific childhood; thank you, Mom! When I was in kindergarten I had a jewelry-making business, making unusual rings and necklaces from colored, dotted telephone wire. Shortly thereafter came the adventures of Popsie, an upside-down pop bottle who roamed my neighborhood in sketches from my cartooning pencil. Then came my introduction to graphic design when I bought a Milton Glaser poster book at a used book sale at the age of twelve. I'll never forget that fortuitous moment, pulling it, corners dog-eared and cover faded, from a pile of softback books tossed in disarray on a dollar table. I was forever changed. Or was I? Had I always been the same? At least in my personality type? My aspirations? My color auras? My perseverance?

This book has reviewed many different theories of inherent qualities with regard to creativity. We are all born to create—to create our next bath, our next meal, our next drive to work, the next blockbuster novel or the next Academy Award–winning movie. What we create is not as important as how we create. Perhaps you don't believe that. I do believe it and the basic premise of this book is that we should find a place where we feel fulfilled by our

> Well, stranger, there isn't any way you can really under-
> stand me, but if you stop trying to change me to look
> like you, you might come to appreciate me.

—*David Keirsey and Marilyn Bates,* **Please Understand Me**

creative aspirations, where we find ultimate happiness and totality some-
where within our creative selves. How we get there is a wonderful journey.

In this chapter I will suggest a number of instruments, some more ac-
ademic than others, that will help you expand your knowledge about your-
self. We seldom take the time to do these aptitude checkups as adults; we
remember taking tests like this throughout our primary and secondary ed-
ucational years; who needs them now? Seeking this information as grown-
ups can help embellish our careers, fostering a newness, a creativity
previously undeveloped, brought about by understanding our processes,
our individual strengths and weaknesses.

We do not need to share this information with others. It is best kept to
ourselves. Exposure to judgment is not the goal. Learning through actual-
ization can teach us how to move forward from a neutral position. Ever
step on the gas when the car is in *N*? It doesn't go anywhere. My Saab has
a "sport" mode that makes me feel like I can pop wheelies when I'm wind-
ing around local mountain roads, unfalteringly confident in rounding the next
corner that all four wheels will stay on the pavement. The instruments dis-
cussed in the following pages will give you new confidence to pursue your
creativity assertively, successfully.

My professional life was forever changed when I discovered the Myers-Briggs Type Indicator (MBTI). I was hired as a production/layout artist for the world's largest grocery wholesaler in 1981. My first day on the job I was asked to answer a series of questions. It looked like a test to me, except the questions were different, easy to answer. I was told that the outcome would teach me many things about myself and that it would help upper management place me into a productive work team.

In actuality, the outcome resulted in my pursuing more information about MBTI, becoming a loyal follower, implementing the instrument as a communication and management tool first at Real Art and now at Global Gardens, my food products company. Every year, since I founded Real Art in 1985, we have held an annual retreat expanding our awareness of Myers-Briggs, using our understanding to respect staff members for their unique qualities. New staff members are required to complete the instrument, and a Myers-Briggs consultant evaluates them individually, explaining their personality type.

Myers-Briggs discovers your personal preferences, which lead to one of sixteen different personality "types." For example, you prefer to be either introverted or extroverted (I or E). You prefer to get your information about the outside world intuitively (N) or by using your senses (S). You make decisions preferably using your emotions, feelings (F), or your thinking (T). Finally, when your mind is active, you are either processing information, perceiving (P), or you are organizing the information and coming to conclusions, judging (J). As with so many other learnings in this book, no single type is right or wrong. Simply becom-

ing aware of your preferences can lead to validation for why you do things a certain way, how you can be most productive and creative.

For example, my type is INTP. This does not mean, however, that I do not enjoy extroverting; on the contrary, I love to speak to large groups. It simply means that I prefer to be with small groups most of the time or have one-on-one conversations. I prefer to use my inherent intuition (N) rather than seek information through my senses. I do make decisions using logic (T) instead of emotion. And I am more flexible and open to changes (P) than my oldest sister, who is a J and enjoys a scheduled, organized, systematic and methodical lifestyle. After doing this for over twenty years, I can readily discern what type my colleagues and loved ones are. It allows me to be more understanding when they choose to do things differently and approach the creative aspects of their lives differently than I do.

The theories of Carl Jung are woven throughout several chapters of my book, and once again Dr. Jung is credited with developing the fundamental theory behind MBTI. According to Jung, there are predictable differences between people based on how they prefer to use their minds. Jung determined that people always preferred one way over another with regard to the eight possible preferences outlined above. Therefore, there are sixteen different personality types. Isabel Briggs Myers and Katharine Cook Briggs are credited with taking Jung's type theory and developing the original MBTI instrument. We should all be thankful for their distinguished achievement. I don't want to sound like a salesperson for MBTI, but it has changed my life and the lives of those close to me professionally and personally. By understanding each other's types, we can give each other the required space, time, psychological

support and veneration to create using our own preferred processes. Understanding your own personal process is imperative to keeping the creative food chain stacked high in cornucopia mode.

Many best-sellers have been written that use MBTI as a foundation. David Keirsey and Marilyn Bate's *Please Understand Me*, Roger Pearman and Sarah Albritton's *I'm Not Crazy, I'm Just Not You: The Real Meaning of the Sixteen Personality Types*, and Naomi Quenk's *Beside Ourselves: Our Hidden Personality in Everyday Life* are three books that are more than useful in learning about our individual types.

MBTI instruments (there are many different versions that offer variations for understanding niche issues) can only be purchased, administered and scored by a qualified practitioner. Certified MBTI practitioners are located in all major metropolitan areas and can be sourced easily through the Internet or by calling the number listed in the resource section at the back of this book. Many psychologists, ministers and spiritual leaders are qualified to administer the MBTI.

The Strong Interest Inventory instrument contains 317 items that measure your interest in a broad range of occupations, work activities, leisure activities and school subjects. This instrument is primarily used to explore career options/changes or organizational development and to enrich or advance our existing careers. It helps to identify interests and then measures the interests and perceived skills for focused career planning. Confidence and enrichment are realized after completing this personal inventory.

Pamala Oslie's *Life Colors* book includes a fifteen-page life colors questionnaire that will provide you with colorful insight into identifying your own personal life color aura (see chapter seven for more infor-

mation). As with any of the instruments outlined in this chapter, it is important that you not complete them if you are suffering from stress of any type. Doing so might result in misrepresentation of your individual data. I completed Pam's life colors questionnaire while I was in total business mode, resulting in my scoring very high as a green, less as a yellow. After my interview with Pam, in a much more relaxed time and environment, I completed the questionnaire again and was surprised to see the major difference. I thought I knew myself better than that!

The Enneagram stimulates self-awareness, self-observation and growth. A book entitled *The Enneagram Made Easy: Discover the Nine Types of People*, by Renee Baron and Elizabeth Wagele takes this somewhat difficult instrument and revolutionizes it into an easy and fun tool you can use every day. It is witty, using cartoons to explain and support much of the information, but it is exceedingly accurate and represents the original complex document in a new and interesting manner. You can find more information on the Enneagram along with other inspirational creativity "tests" at a Web site called jobhuntersbible.com. Don't be put off by the name of the Web site—it's not just for job hunters!

I have introduced *What Color Is Your Parachute?* to countless students and colleagues as a wonderful source of information when questions are being raised regarding self-direction and understanding. Chapter four, "What Do You Have To Offer The World" and chapter five, "Where Do You Want To Use Your Skills?" are especially valuable to help you identify your individual, transferrable skills along with challenging you to realize the importance of enthusiasm and passion for what you do, *and* how you do it.

Careers-by-design.com offers MBTI, Strong and several other instruments along with phone counseling available within twenty-four hours of signing up. This is an abundant source for help in identifying values, preparing a portfolio, preparing for an interview, plus!

I have only reviewed a few of the instruments designed for understanding yourself in a more creative light. Countless workshops are available around the country that support the themes and subjects noted in this chapter. Countless more are available through your local community college, senior center and public service agencies. Once again, the *d* word comes to mind; if we discipline ourselves occasionally to spend the time to make personal discoveries, we will greatly enhance our creative selves. The amount of time invested will be dwarfed by the quantitative outcome. Experiencing self-learning with regard to our personalities and interests promises to guide us to creative utopia!

playing the "instruments"

CHAPTER GUIDES

- There are many psychological aptitude-type tests, or instruments, on the market to help us understand ourselves deeply. A deep understanding of self can allow us to open our creative awareness much more effectively.

- Myers-Briggs (MBTI) is a wonderful instrument that teaches us about our preferences with regard to how we live our lives, how we make decisions, how we perceive others, etc.

- There are predictable differences between people based on how they prefer to use their minds.

- The Strong Interest Inventory instrument contains 317 items that measure your interest in a broad range of occupations, work and leisure activities and academic subjects.

- Do not use any evaluation instruments if you are experiencing stress of any type.

epilogue

◉

CREATIVE UTOPIA

Having finished this book, I am quite amazed in retrospect at how each chapter unfolded and had its own definitive relationship to every other chapter. I did not plan it this way. I had no idea, for example, that Carl Jung introduced the painting of mandalas to the west; I only knew I wanted to include some of his thinking on synchronicity into chapter nine of this book.

It was not my intent for this book to delve too deeply into any one subject matter, either scientifically or philosophically, but rather to introduce to you twelve techniques that, at any given time, might awaken your own creative utopia. There are hundreds of books, Web sites and articles on every one of these subjects reviewed in the chapters here. I have extrapolated my own thinking and personal style for each of the subjects chosen, hoping to intrigue you to entertain new mental paradigms, developing awarenesses of your own.

Discovering your creative utopia is a constant practice. It's like a relationship; as soon as we get complacent, it seems to wane, taking on unsavory characteristics. Instead of starting all over again, make it a challenge to maintain your exploration concurrent with your daily activities. This in itself is a challenge, I know, because of all the diversions that constantly bombard us.

You can't source creative utopia like a book that is out of print or an old toy that might show up on eBay. You must be open to receiving it and challenge your subconscious by consciously learning new approaches to your creative freedom. Techniques such as meditation, feng shui, color therapy, and so on contain proven concepts for opening up previously blocked channels. No amount of money or mechanical knowledge is helpful here!

Creative utopia is something that we don't win; we can't attain it by being lucky. Instead, we work hard for it, earning it by ourselves, for ourselves. Great expectations can get us into big trouble. They allow us to live via false pretense in a fantasy land, just waiting for that yellow brick road. Instead, we must first

design the bricks, manufacture them single-handedly and lay the yellow brick road ourselves. It's quite a journey and requires quite a commitment to process. Ironically, I wonder if L. Frank Baum was aware that the color yellow represents creativity in auras? After all, isn't creativity what Dorothy was ultimately searching for?

For many years I had a personal, unwritten code for judging my own creativity. It was awful. I try now never to heed it, having spent precious energy in active duty, fighting it off. I think that people who strive to own the perception of creativity, who dare to call themselves creative, or label ourselves within that category believe it to be an affluent position within which to revel. Do we deserve it? Should we get permission from someone else? Our critics? Our peers? I was deeply saddened in my unsuccessful quest for this approval from others. Even when I did get the approval, it wasn't enough; it seemed superficial.

The findings of my research, my understanding of the themes in this book and over forty years of applying them have allowed me to realize a joy that can only be brought on by a gift to myself: Freedom from judgment, freedom to apply new learnings, freedom to move from complacency, freedom to realize, freedom to perceive my creativity—utopia at last! It is the ultimate gift that can only come from within, one that we must bestow upon ourselves.

I am interested in knowing how this book helped you. Please send any correspondence to me at one of these addresses:

P.O. Box 557
Los Alamos, CA 93440

theo@globalgardensgifts.com

bibliography and suggested reading:

◉

CREATIVE UTOPIA

Albom, Mitch, 1997, *Tuesdays With Morrie: And Old Man, a Young Man, and Life's Greatest Lesson,* Doubleday, New York.

Allardice, Pamela, 1994, *The Art of Aromatherapy: A Guide to Using Essential Oils for Heath and Relaxation,* Cresent Books, New York.

Beebe, Steven A., and Masterson, John T., 1997, *Communicating in Small Groups: Principles and Practice,* 5th ed., Longman, New York.

Bstan'dzinrgyamtsho, Dalai Lama XIV, and Cutler Howard C., 1998, *The Art of Happiness,* Riverhead Books, New York.

Covey, Stephen R., 1990, *The Seven Habits of Highly Effective People: Restoring the Character Ethic,* Fireside Books, New York.

Fretwell, Sally, 2000, *Feng Shui: Back to Balance: An Entertaining, Lighthearted, Commonsense Approach*, Birthwrite Publishing, Waynesboro, VA.

Goldberg, Natalie, 1997, *Living Color: A Writer Paints Her World*, Bantam Books, New York.

Gray, John, 1999, *How to Get What You Want and Want What You Have: A Practical and Spiritual Guide to Personal Success*, HarperCollins, New York.

Halberstam, Yitta and Leventhal, Judith, 1997, *Small Miracles: Extraordinary Coincidences From Everyday Life*, Adams Media, Holbrook, MA.

Gawain, Shakti, 1978, *Creative Visualization*, Whatever Publishing, Berkeley, CA.

Goleman, Daniel, 1995, *Emotional Intelligence*, Bantam Books, New York.

Jeffers, Susan, Ph.D., 1987, *Feel the Fear and Do It Anyway*, Harcourt Brace Jovanovich, San Diego, CA.

Johnston, William, 1997, *Christian Zen*, Fordham University Press, New York.

bibliography and suggested reading

Jung, Carl, 1989, *Memories, Dreams, Reflections*, Vintage Books, New York.

Kornfield, Jack, 1993, *A Path With Heart: A Guide Through the Perils and Promises of Spiritual LIfe*, Bantam Books, New York.

Lagatree, Kirsten M., 1998, *Feng Shui at Work: Arranging Your Work Space for Peak Performance and Maximum Profit*, Villard, New York.

Lao-tzu, 1990, translation by Mair, Victor H., Tao Te Ching, Bantam Books, New York.

Little, Stephen and Eichman, Shawn, 2000, *Taoism and the Arts of China*, Art Institute of Chicago, Chicago, in association with the University of California Press, Berkeley, CA.

Luman, Stuart and Cook, Jason, "Knocking Off Napster," *Wired*, January 2001, pp. 89.

Mahesh Yogi Maharishi, 1995, *Science of Being and Art of Living: Transcendental Meditation*, Meridian, New York.

Midda, Sara, 1990, *Sara Midda's South of France: A Sketch Book*, Workman Publishing, New York.

Moore, Thomas, 1996, *The Re-Enchantment of Everyday Life*, HarperCollins, New York.

Nhat Hanh, Thich, 1996, *Be Still and Know: Reflections From Living Buddha, Living Christ*, Riverhead Books, New York.

Nhat Hanh, Thich, 1993, *For A Future to Be Possible: Commentaries on Wonderful Precepts*, Parallax Press, Berkeley, CA.

O'Keeffe, Georgia, 1988, *Some Memories of Drawings*, University of New Mexico Press, Albuquerque, NM.

Oslie, Pamala, 2000, *Life Colors: What the Colors in Your Aura Reveal*, New World Library, San Rafael, CA.

Progoff, Ira, 1987, *Jung, Synchronicity, and Human Destiny*, Julian Press, New York.

Rainer, Tristine, 1978, T*he New Diary: How to Use a Journal for Self-Guidance and Expanded Creativity*, St. Martin's Press, New York.

Roth, Gabrielle, 1989, *Maps to Ecstasy: Teachings of an Urban Shaman*, New World Library, San Rafael, CA.

Schwartz, David J., Ph.D., 1959, *The Magic of Thinking Big*, Prentice-Hall, Englewood Cliffs, NJ.

Steiner, Rudolf, 1995 translation by Lipson, Michael, *Intuitive Thinking as a Spiritual Path: Philosophy of Freedom*, Anthroposophic Press, Hudson, NY.

Stine, Jean Marie, 1997, *Double Your Brain Power: Increase Your Memory by Using All of Your Brain All the Time*, Prentice-Hall, Englewood Cliffs, NJ.

Stone, Hal, Ph.D., and Winkelman, Sidra, Ph.D., 1989, *Embracing Our Selves: The Voice Dialogue Manual*, New World Library, San Rafael, CA.

Sun, Howard and Dorothy, 1993, *Color Your Life: A Fascinating Introduction to Color Therapy and How You Can Use It for Healing and Harmony in Bind, Body and Spirit*, Ballantine Books, New York.

Wydra, Nancilee, 1996, *Feng Shui: The Book of Cures: 150 Simple Solutions for Health and Happiness in Your Home or Office*, Contemporary Books, Chicago, Illinois.

resource guide

1. Setting Goals For Success

Feel the Fear and Do It Anyway
Susan Jeffers, Ph.D.

The Magic of Thinking Big
David J. Schwartz, Ph.D.

The 7 Habits of Highly Effective People
Stephen R. Covey

The Magic Lamp: Goal Setting for People Who Hate Setting Goals
Keith Ellis

The 15 Second Principle: Short, Simple Steps to Achieving Long-Term Goals
Al Secunda

Personal Goal Planner
Gary Ryan Blair

2. Keeping a Journal

Personal Memoirs/Journals:

Living Color: A Writer Paints Her World
Wild Mind: Living the Writer's Life
Natalie Goldberg

Sara Midda's South of France: A Sketch Book
Sara Midda

Tuesdays with Morrie: An Old Man, a Young Man, and Life's Greatest Lesson
Mitch Albom

Guided Journals/Journaling Advice:

How to Keep a Sketchbook Journal
Claudia Nice

All About Me
Philipp Keel

Body Confident: A Guided Journal for Losing Weight and Feeling Great
Victoria Moran

From Dreams to Discovery: A Guided Journal
Joan Mazza, M.S.

Life is Good: A Guided Gratitude Journal
Caroll McKanna Shreeve

The Book of Self Acquaintance: A Guided Journal
Margaret Tiberio

The New Diary: How to Use a Journal for Self-Guidance and Expanded Creativity
Tristine Rainer

Things That Tick Me Off!: A Guided Journal
Joan Mazza, M.S.

What Really Matters to Me: A Guided Journal
Robyn Conley-Weaver

3. Becoming Wireless in a Wireful Society

Yoga, Aromatherapy, and Zen:

My Yoga Journal: Guided Reflections Through Writing
Victoria Moran

Kundalini Yoga: Unlock Your Inner Potential Through Life-Changing Exercise
Shakta Kaur Khalsa

Yoga Journal's Yoga Basics: The Essential Beginner's Guide to Yoga for a Lifetime of Health and Fitness
Mara Carrico

Living Yoga—A.M./P.M. Yoga for Beginners Set, VHS tape
Yoga for Beginners; Patricia Walden

The Illustrated Encyclopedia of Essential Oils: The Complete Guide to the Use of Oils in Aromatherapy and Herbalism
Julia Lawless

The Art of Aromatherapy: A Guide to Using Essential Oils for Health and Relaxation
Pamela Allardice

Ancient Secret of the Fountain of Youth
Peter Kelder

A.M./P.M. Yoga Melodies, Audio CD
Brian Scott Bennett

Musical Massage: Resonance, Audio CD
Jorge Alfano

Sanctuary: Music from a Zen Garden, Audio CD
Riley Lee

4. Feng Shui

Feng Shui at Work: Arranging Your Work Space to Achieve Peak Performance and Maximum Profit
Kirsten Lagatree

Feng Shui: Back to Balance
Sally Fretwell

Feng Shui Step by Step: Arranging Your Home for Health and Happiness
T. Raphael Simons

Feng Shui: The Book of Cures: 150 Simple Solutions for Health and Happiness in Your Home or Office
Nancilee Wydra

The Western Guide to Feng Shui: Six-Tape Audio Program and Workbook, Audio Cassette
Terah Kathryn Collins

The Illustrated Encyclopedia of Feng Shui: The Complete Guide to the Art and Practice of Feng Shui
Lillian Too

www.wofs.com
The first online Feng Shui magazine in the world.

www.168fengshui.com
Traditional consulting and educational firm: attend a seminar or enroll in an online Feng Shui class.

www.fengshuidesigns.com
Purchase feng shui products and art such as mirrors, crystals, wall hangings, silk paintings, charms, jewelry and figurines.

Feng Shui Tune Up, Audio CD
Marina Lighthouse with Grand Master Lin Yun

Feng Shui: Chinese Art of Design and Placement, VHS video
Helen Jay; James Jay

Feng Shui (3 CD), CD-ROM
Multimedia 2000, Platform: Windows 95/98/Me

5. Mandalas

Creating Mandalas: For Insight, Healing and Self-Expression
Susanne F. Fincher; Robert A. Johnson

Everyone's Mandala Coloring Book
Monique Mandali

Mandala: Luminous Symbols for Healing
Judith Cornell

Mandalas of the World: A Meditating & Painting Guide
Rudiger Dahkle

www.netreach.net/~nhojem/jung.htm
Discover Carl Jung's notes and quotes on mandalas.

Mystical Mandala, Audio CD
Various Artists

6. Thinking Outside the Box

Be Still and Know: Reflections From Living Buddha, Living Christ
Thich Nhat Hanh

Create a Life That Tickles Your Soul: Finding Peace, Passion & Purpose
Suzanne Willis Ph.D. Zoglio

Eat Mangoes Naked: Finding Pleasure Everywhere and Dancing With the Pits
Sark

Don't Sweat the Small Stuff—and it's all small stuff
Richard Carlson

Spilling Open: The Art of Becoming Yourself
Sabrina Ward Harrison

7. Seeing Color

Color Your Life: A Fascinating Introduction to Color Therapy and How You Can use It for Healing and Harmony in Mind, Body and Spirit
Howard Sun; Dorothy Sun

Life Colors: What the Colors in Your Aura Reveal
Pamala Oslie

Chakras: Energy Centers of Transformation
Harish Johari

Your Aura & Your Chakras: The Owner's Manual
Karla McLaren

Aura Awareness: What Your Aura Says About You
Jennifer Baltz

The Designer's Guide to Global Color Combinations
Leslie Cabarga

8. Brainstorming

Creativity Games for Trainers: A Handbook of Group Activities for Jumpstarting Workplace Creativity
Robert Epstein (McGraw-Hill Training Series)

101 Creative Problem Solving Techniques: The Handbook of New Ideas for Business
James M. Higgins

Collaborative Creativity: Unleashing the Power of Shared Thinking
Jack Ricchiuto

Thinkertoys (A Handbook of Business Creativity)
Michael Michalko

The Art of Innovation: Lessons in Creativity from Ideo, America's Leading Design Firm
Thomas Kelley

www.brainstorming.co.uk
Free training in advanced and traditional brainstorming.

9. Fateful Encounters

Synchronicity
Carl Jung

Memories, Dreams, Reflections
Carl Jung

Soul Moments: Marvelous Stories of Synchronicity—Meaningful Coincidences from a Seemingly Random World
Phil Cousineau

The Power of Flow: Practical Ways to Transform Your Life With Meaningful Coincidence
Meg Lundstrom; Charlene Belitz

www.skepdic.com/jung.html
Learn more about Carl Jung and synchronicity.

10. Meditation

Science of Being and Art of Living: Transcendental Meditation
Mahesh Yogi

The Mind: Its Projections and Multiple Facets
Yogi Bhajan; Gurucharan Singh Khalsa

Dalai Lama: Secular Meditation, VHS video
The Dalai Lama speaks on mental equanimity and the human experience.

Meditation for Starters, VHS video
David Bingham, Director
Instruction and a beautiful guided meditation for beginners.

www.TM.org
The official site of the transcendental meditation movement.

Philosophy, The Rainbow Connection Bath Oils
Includes meditation journal, 7 bath oils and 28 oracle cards, available at www.drugstore.com

resource guide

Zen Notes, Audio CD
Shastro & Nadama

Nataraj, Audio CD
Deuter, Osho Active Meditation (Series)
Dance as a total meditation.

Harmony, Audio CD
Dan Gibson; Hennie Bekker

Tibetan Chakra Meditations [LIVE], Audio CD
Ben Scott; Christa Michell

11. Intuitive Thinking

Awakening Intuition: Using Your Body-Mind Network for Insight and Healing
Mona Lisa Schulz; Christiane Northrup

Developing Intuition: Practical Guidance for Daily Life
Shakti Gawain

Some Memories of Drawings
Georgia O'Keeffe

Discover Your Passion: An Intuitive Search to Find Your Purpose in Life
Discover Your Passion Workbook
Gail A. Cassidy

Do What You Love, the Money Will Follow: Discovering Your Right Livelihood
Marsha Sinetar

12. Playing the Instruments

Beside Ourselves: Our Hidden Personality in Everyday Life
Naomi Quenk

I'm Not Crazy, I'm Just Not You: The Real Meaning of the Sixteen Personality Types
Roger Pearman; Sarah Albritton

Please Understand Me: Character and Temperament Types
David Keirsey; Marilyn Bates

CREATIVE UTOPIA

The Enneagram Made Easy: Discover the 9 Types of People
Renee Baron

What Color is Your Parachute?
Richard Nelson Bolles

www.personalitytype.com
This is the site of two authors, Barbara Barron and Paul Tieger, who write personality books focusing on the Myers-Briggs method.

www.ennea.com
This site explains the nine different types of personalities and offers workshops, books and other resources to help you determine your personality type.

www.jobhuntersbible.com
This site features information from the book *What Color is Your Parachute?* With online personality tests and quizzes.

Additional Creativity Resources:

Celebrate Your Creative Self: Over 25 Exercises to Unleash the Artist Within
Mary Todd Beam

Creativity: Flow and the Psychology of Discovery and Invention
Mihaly Csikszentmihalyi

Creativity for Graphic Designers: A Real-World Guide to Idea Generation—From Defining Your Message to Selecting the Best Idea for Your Printed Piece
Mark Oldach

Creative Jolt: Jump Starts for Graphic Design Problems
Denise M. Anderson; Rose Gonnella; Robin Landa

How to Think Like Leonardo da Vinci: Seven Steps to Genius Every Day
The How to Think Like Leonardo Da Vinci Workbook
Michael J. Gelb

The New Drawing on the Right Side of the Brain
Betty Edwards

Free Your Creative Spirit
Vivianne Crowley; Christopher Crowley

resource guide

The Artist's Way: A Spiritual Path to Higher Creativity
The Artist's Way Creativity Kit
The Artist's Way Morning Pages Journal
Julia Cameron

Point Zero: Creativity Without Limits
Michell Cassou

Why Are You Creative?
Hermann Vaske

http://freespace.virgin.net/david.weeks5/map
This creativity web site presents itself as the Mental Athletics Programme
and even includes a creativity gym.

www.gocreate.com
This is a comprehensive web site on creativity, with articles, tips and
quotes on being creative.

www.enchantedmind.com
This site is filled with puzzles, humor, science and seminars that promote
creative thought and a maximum use of the mind.

www.creativityforlife.com
This site has links to articles and messages on fostering creativity at home
and in the workplace.

Creativity Instructors:

www.taoscreativity.com
This organization based in New Mexico sponsors creativity "camps" that
are affiliated with the *Artist's Way* books.

www.healingartjourneys.com/workshops.htm
This site offers creativity retreats in various international locations each year.

www.creativity-engineering.com
This company based in Denver, Colorado uses Improv (comedy and theater)
to jump outside of the box for teambuilding and creativity training seminars.

www.appliedcreativityinc.com
This Florida-based company delivers eight unique training programs and
seminars that teach people how to rediscover their innate creativity and
organizations how to become more innovative.

CREATIVE UTOPIA

Several trademarked companies/products/organizations/disciplines, etc. are mentioned throughout the text. The author uses these references with respect and lists them here as a courtesy:

DayPlanner

PalmPilot

Visor

Kenneth Cole

National Public Radio

Crayola Crayons

Barbie Doll

Walt Disney World

Global Gardens

Bigelow Tea Company

Nike Corporation

Post-It Notes

Ford Explorer

Worldwide Transcendental Meditation

Myers-Briggs Type Indicator

Strong Interest Inventory

Other credits:

P. 40–41 © Sara Midda

P. 106–107, 112–113 © Aura photography and analysis provided by Progen

P. 141 © 1990 Matthew Brozostoski